MUSLIMS *of the* WORLD

MUSLIMS *of the* WORLD

PORTRAITS AND STORIES
of Hope, Survival, Loss, and Love

Sajjad Shah *and* Iman Mahoui

Foreword by Yasmin Mogahed *with Photography by* Ala Hamdan

Abrams Image, New York

LOVED ONES

To the ones beneath whose feet paradise lies.

To the ones who always listen to our cries.

To Samina Shah and Malika Mahoui, our beloved mothers,
The ones who took care of us before all others.

To Ballal Shah and Abdelaziz Mahoui, our heroes from the start,
our fathers, our inspirations, the ones who stole our hearts.

To Asmaa and Ilhaam Mahoui, my sisters and my best friends,
I promise our love is like time, it never ends.

To Hasan, Humza, Jamal, and Adil Shah, my brothers for life,
you've been with me through it all, through the turmoil
and the strife.

To Our Creator we just want to say,
Forgive us for the mistakes we have made and don't ever let us stray.
Any good that comes about is only from You,
And any mistake is from us and came only from what we do.

And to our beloved readers we present a request:
Pray for us and our families, and we hope that we honor you
by having done our very best.

foreword

A few months ago, I reconnected with my former principal. Ten years after I taught at his school, I had the chance to sit down with him and catch up. He was an older gentleman in his final year before retirement. Although I had only worked with him for a year, and a decade had passed since we'd last seen each other, I had never forgotten his kind soul.

As we spoke, I came to learn that the last few years were full of tragedy for Dr. Jitmoud. He told me about the death of his wife, may God have mercy on her soul, after a long battle with cancer. But it was the story of his son that became etched in my mind. Dr. Jitmoud told me of the horrible night his son was delivering pizzas, and at 3 A.M., Dr. Jitmoud received a call informing him that his son had been murdered on the job.

In that moment, this dear old friend taught me that life is only partially what happens to us. The rest is how we react. He told me that what followed for him was a period of grieving and pain. But something else was born out of his grief. When we are pushed to the edge of our emotions, we can either collapse, or we can expand. This man expanded. He soon requested to meet with the killer of his son. The killer was on death row, but Dr. Jitmoud pleaded for two years to get one chance to face him in person. I asked him why he was so eager to meet his son's killer, and his response floored me. He said simply, "I want to meet him so I can forgive him. I want him to end up in the same place as my son."

A few months after our meeting, Dr. Jitmoud met his son's killer in court. He hugged him, and on behalf of his late wife and himself, he forgave the man who slaughtered his son.

Dr. Jitmoud is a Muslim. His story is exceptional, but it is also part of a larger legacy of untold Muslim narratives. A book like this could not have come at a better time. With widespread Islamophobia and new legislation targeting Muslims, our nation's fabric is being threatened by the disease of racism and bigotry.

French author Antoine de Saint-Exupéry writes, "Only the unknown

frightens men." When something is distant or not fully understood, it can easily look threatening. Outside of politicized sensationalism, the real lives of everyday Muslims have been obscured by the media. Therefore, too many of those outside the faith have failed to see Muslim people as human. This book tells the stories of Muslims from all over the world, living the same human experience as everyone else, going through the same kinds of pain and triumphs. It tells stories of humans who have loved and lost, struggled and fallen, but who have found the courage and resolve to get back up and keep moving. This book is a collage of testimonies to the resilience of the human spirit, when it refuses to let death and hate win. These are souls who have found the strength in their faith to keep going. These are people who have found hope in the most hopeless of places. These are people who have stood up and said that they will not let that hope go.

The Prophet Muhammad (*PBUH*) says, "The community is like one body. When a part of that body is in pain, the whole body reacts with fever."

To see is to know. And to know is to finally understand and accept. The more of the lives of Muslims we all see, the more we can start to appreciate one another less as foreign pieces and more as integral parts of a single human body, living a shared human experience.

—*Yasmin Mogahed*

preface

We were born Muslim, in Muslim homes. Most of our lives we have known Muslims, loved Muslims. We learned the meaning of unconditional love from our mothers and fathers, some of whom were American born and some of whom were immigrants. Growing up, we never viewed the people in our lives— our friends and mentors—through a filter of religion or race. Each individual had intrinsic value, something to teach us, a new perspective to show us. But when we came of age we realized that the rest of the world did not necessarily view us—Muslims—the same way. We were seen as one dimensional, not capable of love or compassion. Misconceptions about who we are broke our hearts. But sadness is a funny thing. It can take us to dark places, but it can also help us bring more light and more love into the world. In this way, our sadness and frustration are what inspired us to start this project.

 Muslims of the World was created as a platform for those of us who felt like their faith and identities were slowly being taken away by the few who choose to commit acts of violence. This project started small, as an Instagram account that featured stories of users who believed that their own struggles and successes, as well as those of their mothers, fathers, brothers, sisters, and friends, had the potential to inspire others. Muslims, Christians, atheists, Buddhists, and people of other faiths have come together on @muslimsoftheworld1, bonding over their shared humanity. Comments on photos sometimes spawned heated debates about philosophy, politics, and even fashion, allowing users to forge friendships and relationships that could last for a lifetime. The stories about love, forgiveness, faith, and social injustice alike have garnered widespread support, sometimes going viral—all due to our amazing and engaged community.

 We started Muslims of the World because we wanted to share stories that would drive people to love one another. This feels especially important today, in a world in which it often seems easier to hate than to love. The goal of Muslims of the World is not to portray Muslims in any specific light; instead, it is to share stories about who we are. Islamophobia is unique in that Muslims

are not only judged by the color of our skin or the way that we dress but also for our religious beliefs. The level of racism and prejudice toward Muslims has only increased since the beginning of the twenty-first century, and the hateful rhetoric and misconceptions propagated by politicians and media outlets have served to legitimize the opinions and actions of those who seek to harm us. Muslims are human beings struggling with the same challenges that everyone faces, forging through successes and failures, hardships and comfort. This is the mission of this project: to alleviate the suffering and oppression of others; to share stories of compassion that have no boundaries; to show how charity, clarity, and forgiveness create a path that allows us to see past our differences.

We believe that to truly understand another human being is to fall in love with them. The Prophet Muhammad (*PBUH*) once said: "You will not enter paradise until you have faith, and you will never complete your faith until you love one another." Without a genuine appreciation and love for one another, there can never be genuine understanding between neighbors and families, colleagues and classmates. And it is in gaining an understanding of others that we gain an understanding of ourselves. This common movement toward tolerance, justice, and equality is what makes *Muslims of the World* possible. We never imagined that this project would get the kind of response that it has received. To witness the love and passion that has poured into this project from people all over the globe has been one of the most amazing experiences of our lives.

We want to share with you some of the journies that were shared with us, from ordinary Muslims with extraordinary stories. These stories focus on fate and faith, refugees, racism and prejudice, the *hijab,* female empowerment, prayer, and love—stories that, at their core, present the true nature of Muslim people. We chose these chapters to serve as a reminder that social justice should matter to everyone, that the refugee crisis is a humanitarian issue and not just a Muslim one, and that stories of love and fate are universal. Our hope is that as you read these stories of sadness, compassion, frustration, and joy, you will understand that no matter where we come from, Muslims are simply human beings.

—*Sajjad Shah and Iman Mahoui*

faith and fate

So remember me, I will remember you.
(Surah Baqarah 2:152)

What is faith? We can define it, at the
very least, as complete trust. Faith has
brought peace of mind to billions and has
helped many find solace in times of need.
Faith comes in many forms, but religions,
as institutions, have shaped the world we
live in.

Islam, the world's second-largest religion, and the fastest-growing religion to date, is also arguably the most misunderstood and the least accurately represented by mainstream media. But for the billions of Muslims who practice this faith, our religion is one of beauty, kindness, compassion, generosity, and tolerance. Muslims, as part of the basic tenets of our faith, fast during the month of Ramadan to remember that we live in a world where many go hungry each day. We also give charity, not only to help those in need, but as a reminder that this world, and all its material goods, is temporary. As a religion, Islam has brought together members of all races, ethnicities, and social classes under one umbrella, and inspired them to live by a code of kindness and empathy, following in the footsteps of the last Prophet, Muhammad (*PBUH*).

There are six pillars of faith, or *Iman*, in Islam. Belief in Allah, the one God; belief in the Angels; the Holy Book (the Quran); the Prophets; the Day of Judgment; and belief in God's predestination (*Qadr*). Through these pillars, Muslims build upon the teachings of the Prophet Muhammad and the Quran in order to guide their day-to-day lives. These teachings are stories of kindness and compassion in the face of anger, generosity in times of shared hardship, humility in times of success and failure, and, of course, patience when facing all of the trials and tribulations that life has to offer. Attaining that steadfast patience, however, is difficult for all of us, and can only be understood as a willingness to trust the process. This is where *Qadr* comes in to play.

Fate is a universal concept not specific to Islam. To most, the idea that something is "meant to be" provides solace when thoughts of an unknown future arise. We live in a world of unknowns; the reality that anything can be taken away from us at any given moment scares us. For some, that fact drives them to live every day as if it is their last, but for others it can be crippling. Whether it comes from "God" or "gods," "the powers that be," "karma," or something else, there comes a moment of realization for us all when we must accept that no matter how hard we may try, not everything in life is within our control.

The concept of *Qadr*, or "predestination," is the foundation on which all aspects of the Islamic faith stand. However, fate is a tricky subject, as one may wrestle with the concept of free will and how these two seemingly antithetical concepts could possibly coexist. A story from the Prophet Muhammad's time might help elucidate the subject: One day the Prophet noticed a man leaving his camel in the desert without tying it, and he asked the man,

"Why don't you tie down your camel?" The man answered, "I put my trust in God." The Prophet responded, "Tie your camel first, then put your trust in Allah."

Fate is what happens when we put our trust in God and realize that what He pleases will ultimately occur. But that's not to say our earthly actions don't have an impact. Accepting one's own vulnerability in the face of God is the first act that tests a believer's faith.

> *And it may be that you dislike a thing which is good for you.*
> *(Surah Baqarah 2:216)*

It is daunting for many to know that what is best for you in the eyes of God may not be what you would have wanted for yourself. In the face of all of life's hardships, perceiving any lack of control in your life is unnerving, but seeing the work of fate in action—along with faith, and each individual's personal form of worship—can ameliorate that anxiety. Stories of women and men from all over the world who have suffered through incredible heartbreak and injustice yet somehow made it to the other side with humility, strength, love, and a renewed appreciation for this life can be found in every chapter of this book, but we want to begin with stories dedicated solely to those who put their faith in fate.

—*Sajjad Shah and Iman Mahoui*

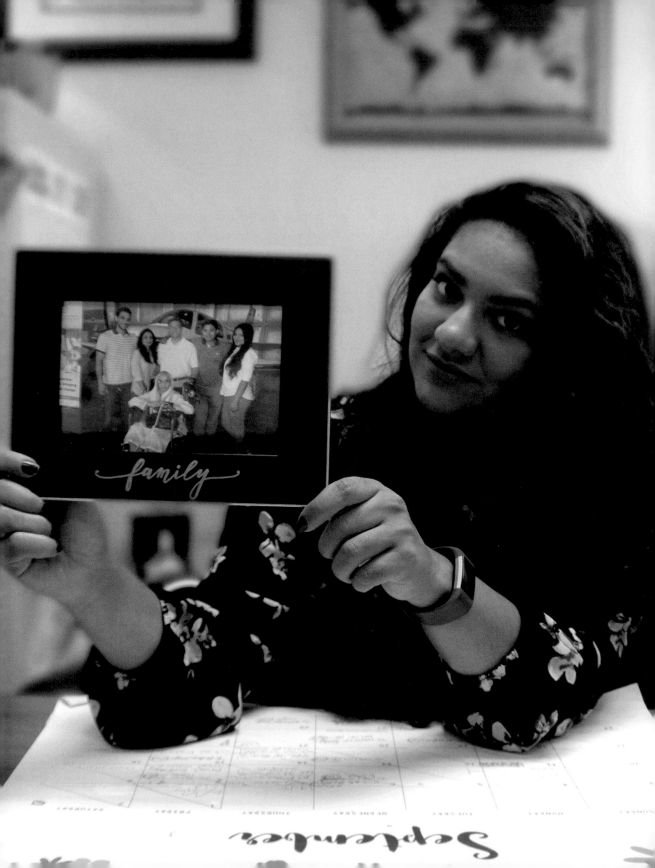

hiba 29, Indianapolis, Indiana, USA

When my dad, Babar, was a kid, he attended an Air Force prep school in Sargodha, Pakistan, which fostered his love for flying and adventure. When a career in the Air Force didn't pan out, my dad became an engineer. He moved to the United States with his new wife and three kids. My dad led a typical Midwestern life. He worked hard, coached soccer, was involved in the local *masjid*, and volunteered whenever he was needed. But he never forgot his love for flying.

My dad realized that he was privileged to receive an education that so few in Pakistan can afford. He always made sure to give back. He donated to shelters for runaway kids; he gave money to an acquaintance whose home had burned down; he even helped pay for a stranger's college tuition when he heard that person didn't have enough money. My dad always gave twice as much when it came to education. He believed wholeheartedly that whatever he gave would be returned tenfold.

It was no surprise when my dad decided to combine his dual loves for giving and flying by flying around the world for charity to promote children's education in Pakistan. My younger brother Haris and my dad decided to embark on the flight together. Haris had started flight school the year before and decided to get his pilot's license for the trip. He would be pilot in command. When they completed the trip, Haris would be the youngest pilot to circumnavigate the globe. On June 19, 2014, they took off from Greenwood, Indiana. They flew to Canada, Iceland, England, Pakistan, Sri Lanka, Bali, Australia, and the beautiful island of American Samoa. Along their journey, they saw the ruins of Rome, the pyramids of Egypt, and the architectural wonders of Dubai.

Just two days away from home, excited to be returning to Indiana in time for *Eid*, my dad and brother took off from American Samoa en route to Hawaii. They crashed upon takeoff. Neither of them survived. Haris's body was found within hours. My dad, and the wreckage of the plane, were never found.

Many people ask me, "Why did they go on such a dangerous journey? Why did they put themselves at risk?" My dad's response would be simple: "Why not?" In a blog documenting their journey, my dad wrote on July 6, 2014:

"Here is something my wife and I very strongly believe in: If it's not your time, it's not your time, but when it is—no matter how many iron curtains you hide behind, the grim reaper will get you. But if you go supporting a noble cause, you have made a point and achieved your goal."

My dad and brother knew the risks, but they also knew that fate is not something you can escape from. Their fate was to fly around the world together, raise thousands of dollars, and ultimately lose their lives for a cause they believed in. My fate was to lose my father and brother and deal with the pain of not being able to bury my father. My fate was to be a "younger" sibling for seventeen years of my life, only to then become the "youngest." My fate was to struggle with the grief of a quiet house without the noise and chaos of a younger brother.

But that's not all. My fate was also to see the legacy my father and brother left behind. Millions of dollars in donations poured in from well-wishers who were inspired by their story. Hundreds of schoolchildren will benefit from my father and brother's sacrifice. Their story has been immortalized in articles and a documentary. My fate was to travel to Egypt and Pakistan to retrace the steps of their incredible journey. And my fate was to finally realize that even in the darkest of times, when finding hope seems like an impossible task, Allah (*SWT*) will shine a light to help you find it.

Sometimes I'm angry about the way things turned out. But then I remember the silver lining buried in our loss. My dad and brother were ready to take a risk for something greater than themselves. In the end they were called back to their creator and called *Shaheed* by those they left behind. While nothing can fill the hole they left in our hearts, they died leaving behind *sadaqah jariyah*, or unending charity. They set an example of how to facilitate change in the world, and I now aspire to achieve this same goal. How can I be angry with that fate?

My fate was
also to
see the legacy
my father
and brother left
behind.

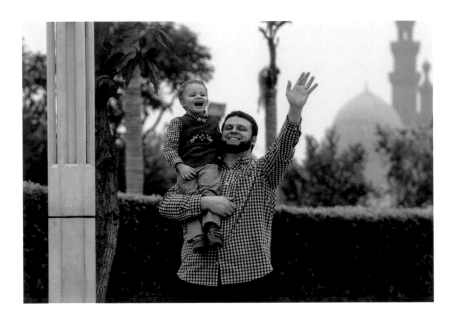

chad *37, Cairo, Egypt*

I was born in a small town in southern Indiana (think almost all white and Christian). I also grew up in a single-parent home. Our family was Christian, but growing up, our church attendance was spotty. In fourth grade, we moved to a slightly larger but still small town that was also the site of the main campus of Indiana University. Shortly after the move, I remember watching a TV sitcom called *True Colors* about an interracial couple, both of whom had teenage children from previous marriages. In one episode, the youngest son, a black teenager about fourteen or fifteen years old, was given a copy of *The Autobiography of Malcolm X*. As he read it, he started to imitate Malcolm's early, antiwhite rhetoric, humorously directed at his stepmother and the rest of her family. He even targeted his father for being an "Uncle Tom" who was lured into the "trap of the white woman." As a white boy from an area with very few minorities, the idea that there was a man who called white people "evil" and "devils" was so intriguing that I begged my mom to take me to the bookstore to buy Malcolm X's book.

I remember when I got my hands on it. I couldn't stop looking at the cover. I remember struggling to read and understand it. I wasn't the best reader to begin with, and at eleven or twelve years old, the concepts and history

Malcolm discusses went somewhat over my head. To my surprise, Spike Lee released a film about Malcolm's life not long after, which helped me visualize and understand his story better. I was in awe of this man, may God have mercy on him. The two most important things I loved about him (and still do) were the fact that he lived by his principles, no matter the worldly cost of doing so, and that he was humble enough to accept when he was wrong and would change his opinions and lifestyle accordingly. How many of the world's problems would be solved if we all could live our lives following those two tenets? After having seen and understood the beauty that was Malcolm X, I myself went through a period of imitation. I stopped eating pork because Malcolm said it was bad. Although my mother probably thought there was something wrong with me, she didn't force me to eat it, and she eventually stopped cooking it.

During this period, I became interested in learning about Islam, since it was one of the driving forces in Malcolm's life. It was 1993, before the internet, and resources were limited. I had never known a Muslim person in real life, and the whole religion seemed distant and out of reach to me. Yet God willed that a family from Afghanistan would soon find their way to southern Indiana, to an apartment just two doors down from ours.

I remember when I first discovered that they were Muslim. The father, may God have mercy on him, was pushing his youngest son, about three years old at the time, on the swing set. I said hello and asked him where he was from. When he said Afghanistan, I wasn't sure if he was Muslim, so I asked him, "Are you Buddhist, or Hindu, or . . . ?" He said, "No, we are Muslim." My heart jumped! I was finally meeting a Muslim! The idea that a family of Muslim people were my neighbors, whom I could talk to face-to-face, was almost unbelievable.

Over the next few years, I became quite close with them, as some of their children were around my age and we had a lot in common. One day I asked their oldest son, Zobair, if he could teach me something about Islam. He humbly replied that his English wasn't very good, nor was his knowledge of Islam, so he'd try to get me some books to read. Not long after that, he delivered a copy of Abdullah Yusuf Ali's translation of the meaning of the Quran (with commentary) and some other reading material. He suggested that I read it and that we could discuss the ideas and concepts along the way.

This was the turning point for me. The more I read about Islam, and the more time I spent around this family, the more I understood this religion. The few ideas that seemed strange to an American, like *hijab*, were easily

explained, and I quickly came to understand them. I was even able to visit the local mosque one Friday during summer vacation. It was a surreal experience. I remember the feeling of standing in the back of the room while everyone else prayed and hearing all of them say "Ameen" at the same time. My heart jumped (again)!

Not long after that, during my freshman year of high school, I accepted Islam into my heart. In a way, it wasn't a strange event. It felt more like I was merely verbally accepting what I had internally accepted for a long time. Learning to practice and live Islam on a daily basis would of course prove more difficult. My mother wasn't too happy with this change in my life, and we found ourselves arguing over the issue more often than not. The Muslim people I had met had all given me advice, which I realize now was also life changing. They told me that no matter what, I had to respect my mother. They said I shouldn't bring up Islam or talk about it if I could help it, since it would only lead to arguments with her. They knew that I could still be a good Muslim without talking about it, and when I graduated from high school, I would be able to practice Islam as I wished. This advice helped me through tough times when I felt very few other people accepted my decision.

After high school I went to college and went through another period of self-discovery, this time focused on trying to find my place in the world. I had thought about going into the field of education while I was in college, but I wasn't sure of myself or where I fit into that field. Over time, I realized that if I was going to teach something, it would have to be something that I loved to study and learn about. As I thought about it more and more, the only thing that I knew I was motivated to study was Islam. After discussing this with friends, I understood that any serious study of Islam would require that I learn Arabic. So in 2005, I moved to Egypt to begin a journey that led to me studying at Al-Azhar University, one of the oldest universities in the world.

In 2010, while in Egypt, I met my wife and her family. In 2011, we married, *Alhamdulillah*, and have been blessed with a son, Yusuf, and a newborn daughter.

If you were to ask me at ten or eleven what I'd be doing twenty or thirty years later, I'm sure that I could never have foreseen the path that my life has taken. But *Alhamdulillah*, Allah deserves all praise for his guidance and favors upon us!

"
Over time,
I realized that
if I was going
to teach something,
it would have
to be something that
I loved to study
and learn about.
As I thought about it
more and more, the
only thing that I knew
I was motivated to
study was Islam.

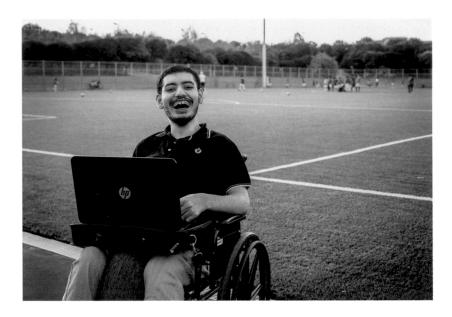

mahmoud *25, Amman, Jordan*

I was born with cerebral palsy, and I couldn't always walk or run like everyone else.
I was passionate about soccer, and despite my challenges I was eventually known
as the best player on the team. But around the age of thirteen I was no longer
able to receive the treatment I needed because it was too expensive. As I grew, my
muscles started dying, until they were no longer strong enough to carry me. Now I
can't walk at all—I can barely move. I can't even move my tongue.
I can only move one finger on each hand, and my neck. I communicate by writing
on my laptop. People read what I write and I listen to their comments and an-
swers. It's a long process even when it's a simple discussion.

My family has been there for me every step of the way. Relatives and
neighbors used to tell my mother that I was a waste of her time, that I should
stay at home and that I wasn't even worth my school's tuition. But my family
believed in me.

I graduated from high school with good grades. Then I went on to
college where I was surrounded by supportive people and friends. Sometimes
I feel that God gave me something special that makes people want to hang
out with me. I don't walk, I don't talk, yet I have great friends whom I love
spending time with. I graduated from college with honors. My parents' eyes

filled with tears when I got my diploma. They sacrificed a lot to make this happen. They had to rent a new house because I couldn't walk up the stairs of the old one, and this put a financial strain on them. Despite all the criticism they received, my parents stood strong.

A couple of years ago I started an initiative for people with special needs. I started touring the country and "speaking" about how powerful a person can be, even if he has only two fingers working. I've talked to hundreds of people about how, as long as you have a working brain, you can own the world. Every time a person tells me they felt better after hearing my speech, I feel like the king of the world!

"In the mosque,
he prays right
next to me,
imitating
everything I do.

"

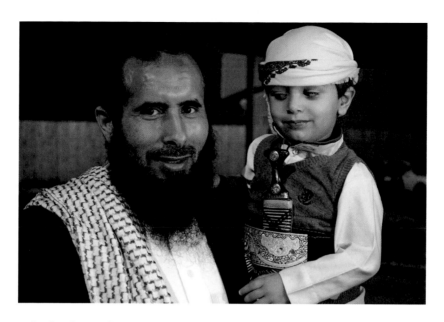

abdulwahab *46, Indianapolis, Indiana, USA*

Coming from a small village in Yemen, I know firsthand that it truly does take a village to raise a child. When I moved to America, I told myself I would buy any home I could find that was close to a local mosque. I wanted my kids to be close to the house of God, so that they could feel that they were part of a community. We currently live about twenty feet away from our mosque. Every day, I dress my son up in nice clothes—fit for the house of God—and we walk with my mother to the mosque. I hold the hand of my son in one hand and the hand of my mother in the other as we make our way there. In the mosque, he prays right next to me, imitating everything I do.

The most important thing for me is to raise my son as a good Muslim. I don't care how much money he makes, or what kind of job he has when he grows up, as long as there is a love for Islam in his heart. I hope to see my son become a kind and compassionate man, and that he walks through life with a quiet strength and humility. It makes me so happy when I see him running around with the other little kids at the mosque. I believe he will have a better future here, with opportunities that only life in America has to offer. No matter the uncertainty of what will happen, America's freedom of religion is what makes this country great. I feel safe raising my son as a Muslim in America.

naser *48, Zarqa, Jordan*

For three days after Abdullah was born, I could not tell my wife that our son had Down syndrome. Our family had never encountered a person with Down syndrome, and I was afraid of my wife's reaction. I told her the baby was sick so I could figure out how to tell her the truth about the situation. I was so scared and for the first time ever did not know what to do.

I was in a pharmacy getting medicine when I saw an old lady in a wheelchair. A man with Down syndrome was pushing the wheelchair. I asked her if he was her son, and she got mad thinking I was judging her. I quickly told her that I had a child like him. She smiled and said, "He is the best thing that has ever happened to me. I have nine other children, but he's the one I'm closest to."

My son Thaer was twelve years old when his new brother was born, and he sensed something was wrong because of how I was acting. When he learned Abdullah had Down syndrome, he said he was upset with God. Thaer said he would stop fasting and praying because he read that only one out of eight hundred families have a child with Down syndrome. Why us? I sat with him and said, "If you have money, and you must choose one family out of eight hundred to keep it safe, wouldn't you pick the best and most trustworthy family? That is why God chose us."

I went back to the hospital and told my wife the truth. I also told her that my sister was willing to raise the baby if she didn't want to. My wife looked at me and said, "I will raise anyone I brought to life. He is my son no matter what." A few days later we went to a café together and promised each other we would never be ashamed of Abdullah, and that we would give him everything he deserved.

I went to the bookshop and bought every book they had about Down syndrome. I called friends who are doctors and asked for advice on how to care for Abdullah. I learned about how Abdullah eats, about his skin, about his brain and his muscles. I read about what we could expect from him in a few years. The books said that Abdullah would be a stubborn boy, and it would be hard to put him in a regular school. I refused to believe this. I decided to send him to an ordinary school, and his classmates love him. Abdullah's behavior gets better as he learns to do things without any special treatment. He calls me his "best friend," and he is mine as well. It's challenging to raise him in a society that thinks so little of him, but he brings joy and happiness to our little family. I take Abdullah to Friday prayers. Once he said, "When you are old, I will bring you here." This meant the world to me.

I talk about Abdullah all the time—on radio stations and on TV. I also write about him. I get many messages from people saying they were ashamed of having a child with disabilities, but after seeing how proud I am of Abdullah, their feelings changed. Abdullah might not be a "normal" kid, but he has the most genuine and pure heart. He loves his family unconditionally, and we love him back.

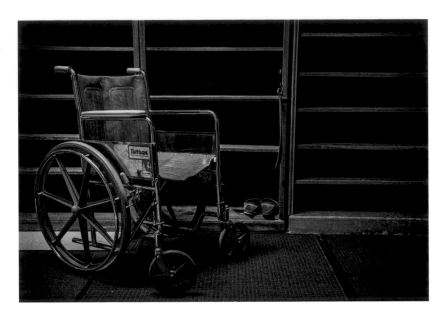

safaa *28, Charlotte, North Carolina, USA*

On a fateful freezing night in 1998, by the will of Allah (*SWT*), my father was hit by a semitruck, and his death seemed imminent. Twenty years later, seeing my daughter—his first granddaughter—in his hands, I pray that Allah allows him to continue to enjoy the freedom of his health, to make us the joy of his eyes and the tranquility of his heart, and to make him a leader in all that is good.

Allah says in the Quran in Surat At-Talaq (65:3), "Allah has already set for everything a [decreed] extent." On the night of my father's accident, he took his final steps on the legs that Allah gifted him at birth. He had just finished buying us toys, all of which were in the trunk of his car that had broken down on the side of the road in Lawrenceville, New Jersey. Those toys would never be added to our messy bedroom floors. As he was standing behind his car, about to open the trunk, he was struck by a semitruck whose driver had apparently dozed off behind the wheel. Unconscious, pinned between the two vehicles, and quickly losing blood, my father remained unattended on the side of the road for close to an hour. The truck driver who struck him had fled the scene. No one was present, but my father was not alone. He was found pulseless, and he lost one leg on site, and the other in the hospital. Medical staff esti-

mated that his pulse had been gone for sixteen minutes after losing five out of his six liters of blood. They measured some electric signals in the brain to see if my father was still alive. A helicopter flew him to the closest trauma center, and a trauma team managed his major internal bleeds, broken neck, punctured lungs, amputated legs, and other critical problems. The conduits through which the mercy of Allah is delivered are diverse and many. On that night, the vessels of mercy included the freezing cold that kept my father alive while help arrived and the medical team that worked hour after hour to save him.

That night, the hospital staff called several numbers from his address book looking for someone who knew him. He was so swollen from the trauma that none of his friends could recognize him. Eventually, a fax was sent to my mother, who was in Egypt, explaining my father's dire condition. I will never forget the sound of my mother's helpless cries as she received that fax.

Alone in the United States, my mother's beloved husband was hovering between life and death. She went to him while her four children remained thousands of miles away in Alexandria, Egypt. My siblings and I each comprehended the situation differently, as our understanding, shock, and grief varied according to our ages: we were a nine year old, a seven year old, a five year old, and a fifteen month old. As a seven year old, all I knew was that my Baba—my love, my hero, my everything—was in trouble and his life was in jeopardy. What I didn't realize was that Allah had sent heroes rushing to his side: my mother, the hero of unwavering faith and trust, and my father's friends, the heroes of support. I didn't know the diligence of the medical staff that performed five major surgeries in the span of weeks.

And eventually, by the mercy of Allah, soon I was walking, and then jogging, and then running toward my mother and father at JFK Airport, a little uncertain at the sight of my father in a wheelchair, but overjoyed to be back with my parents.

My father worked hard to embrace his new life and to ensure that nothing changed for us after his accident. The accident may have taken a part of him in the physical sense, but it left behind a superman who fought his way through a great test to give us a good life. We are forever indebted to him. He was determined to be the best father and husband, and for us to get a balanced Islamic upbringing and strong education, and that left him no option but to make huge strides in his rehabilitation. Throughout his rehabilitation, he made us laugh and even wrestled my brothers. He always won.

Over the past twenty years, my father has shown us that although we do not choose our circumstances, we have full control over how we deal with them. His scars did not disfigure him but shaped him. Allah says, "Surely I have not created this in vain" (Surah Ali Imran 3:191), meaning that not a single leaf that falls or a single tear that is shed is without purpose. Allah helped my father back up, and he became a shining light. He taught us to seek healing by embracing the book of Allah and to find fortitude through constant remembrance of Allah. This was his recipe for dealing with any hardship. Every moment of the accident and its aftermath demonstrated that Allah has divinely selected us for our experiences. My family and I proudly walk alongside Baba, so he does not climb his mountain alone.

molham *22, Dubai, UAE*

I was on a service trip to Urubamba, Peru, with fifteen other University of Tampa students. We were there to support orphanages. We harvested quinoa, cut grass, and painted houses every day from sunrise to sunset. We played soccer with the boys, ate home-cooked meals with the elders, and danced to Beyoncé's "Single Ladies" with the little girls.

During my thirteen days there, I cut myself off from the world—no calls, no texts, and no social media. I wanted to be fully present. I did allow myself two minutes of email a day for two reasons: one was so my mom, dad, and little sister could check in on me and vice versa, and the second was because I was waiting for an email that would decide what I'd be doing for the next few years of my life. Earlier in the year, I had applied as a transfer student to three different undergraduate schools—Georgetown, NYU, and Brown—wanting a new path that would take me on another adventure.

Each night after a hard day's work, I would turn on my phone and sit quietly on the couch in the only room that had Wi-Fi to check for news. Nothing the first day. Nothing the second. On the third day, an email from my mom (God bless her heart). On the fourth, though—a surprise. A message from NYU. It took two whole minutes to download:

"The admissions committee at New York University has carefully considered your application and supporting credentials, and it is with regret that I must inform you that we are unable to offer you admission to NYU this year."

My heart pounded. And while I didn't say a word for the rest of that night, one word kept ringing through my head: "Why?" I didn't understand. But I still had two more chances.

The next day, I received an email from my dad—he wanted to know how I was dealing with the altitude. The day after, complete silence. Then, on the seventh day, I received my admissions decision from Brown. I jumped. This was the moment of truth. And indeed it was—it was the moment I learned that Brown was not in my future, either.

I hated rejection. But in that moment I was struck by an unfamiliar calmness. Later that night, standing in front of the bathroom mirror brushing my teeth, I felt it was going to be okay. I was giving up the need to be in control, and a sense of freedom was ushered into my soul. Lying in bed and staring at the ceiling, I had total confidence that there was a reason for all this. The truth is we rarely know why things happen the way they do, and we often lack the proper foresight and patience. I understood that these decisions were beyond me. My role was to put in the work and pull out all the stops. The result, though, was not for me to determine. Two days later, I got my acceptance to Georgetown University.

jarrah *22, Amman, Jordan*

When I was fourteen years old I was playing soccer when I felt a pain in my thigh. The pain continued for days so my family took me to the hospital. It took four months, but the doctors eventually discovered that I had cancer. All I cared about at that time was playing soccer, getting good grades, and making sure my hair looked good. But all of that changed very fast—we caught the cancer too late, and I lost my left leg.

I went through a lot of pain other than just the physical loss of my leg. I was doing physical therapy to learn how to walk using my artificial limb. After a long day of practicing, a nurse came by and said to me, "You stink! Go take a shower." She didn't understand that I didn't know how to do it alone. I was fourteen years old and needed support all the time. That nurse broke me, but that was just the beginning. I got rejected by a beautiful girl I loved who was also sick. The minute she healed, she told me she couldn't be with me. I also lost some friends who were "too cool" to hang out with a guy who only had one leg.

Despite all the setbacks, I still had a lot of support and tried to be positive. I decided to use this test from God to inspire others. This was a test from God and I wanted to show him that I still had full faith in his plans, for

He is the best of planners. I signed up for a climbing trip. I fell so many times I was black and blue, but by the time I got home I knew what I was meant to do. Today I am considered one of the best hikers in the world with an artificial limb. Nothing stops me, and I even organize trips for children with cancer.

I was interviewed on TV once. After the interview I decided to go back to the hospital to find the nurse who had mistreated me. She said she saw me on TV. I told her I never forgave her for the way she treated me. To be honest, I did forgive her; I just wanted her to know that children remember things, and that pain grows within them. I didn't want her to forget that.

Now I love waking up in the morning. I'm proud of who I am, and I wear shorts for my work. You have a leg made of flesh and blood, and mine is made out of the best metal there is. In a few years you will see my name in *Guinness World Records* as the first man with an artificial limb to have climbed the highest mountains in the world.

lulu *42, New York, New York, USA*

> *Allah is the ally of those who believe. He brings them out from darkness, into the light.* —*Surat al-Baqarah 2:257*

It was a hot summer's day in New York City. The afternoon was dense with humidity that weighed heavily on everyone. I stormed out of the house to get fresh air. My head was about to explode from all the stress building up inside of me. I was a soon-to-be divorced single mother with twins who was living back at home with her parents. I was getting zero financial support for the kids from their father. I had no job, no husband—just broken dreams. Life had never looked so bleak.

Things weren't always so dark. Not long before this day my heart was filled with complete joy. Allah (*SWT*) chose my womb to bring twins into this world. But now I was facing the reality of raising them as a single parent. Who could show me how to make it in this world on my own? I had no role model, no one to guide me. I started to panic about the future: How on earth would I be able to provide for the twins? How would I be able to afford a good school for them? Frustrated and almost resentful, I became someone I didn't like anymore. Even worse, I wasn't sure how I felt about my Creator, either. I was angry. Why me? Why the twins? What did I (or they) do to deserve this life?

I got in my car and little drops of rain began to hit the windshield. The sky was getting darker from a brewing storm. I placed my head on the steering wheel and prayed. I prayed for the rain to wash all my sins and anguish away. I prayed it would wash away all of my bad thoughts. I knew the thoughts I was having were wrong, but they hijacked every part of my being. When I picked up my head I noticed a woman dragging a suitcase, with two kids following behind. It was a busy intersection near the bus stop in front of my house. She looked as lost as I felt, and for some reason, I smiled.

I felt her anxiety and her despair. I decided to get out of the car to ask if she needed help. She said she was looking for a homeless shelter where someone had suggested she stay. Before then, I had never known that there was a homeless shelter in my neighborhood. Since I didn't know where it was, I decided to get back into my car. I started the car and turned on my windshield wipers. They swayed across the glass quickly as the storm came in. Staring out the window, I could see the mom and kids looking worried as thunder rolled through the sky. My heart began to beat quickly, keeping time with the windshield wipers. My initial reaction was to drive off, to go, to run my errands. But I couldn't move. I couldn't leave them behind. Even though we lived in such a busy city, at that moment it felt as though the world stopped and it was just the four of us—and Allah above. When I offered to take her to the shelter, tears rolled down her beautiful, striking cheekbones. I'll never forget what I saw in her kids' eyes. The look of fear, instability, a feeling of not being wanted. They, too, were in despair.

The shelter wasn't far from my house, but I couldn't tell you how long it took us to get there. Time stopped for us as we drove. We weren't a part of the world that day. We were being tested and watched. I know deep inside of me it was no accident or coincidence. I firmly believe we both had the same feeling. Our lives mirrored each other's: we were two young, divorced single mothers who had left abusive relationships, were unemployed, and had to care for a boy and a girl. We were both broken. The only difference between us was that I had a family to help support me; she did not.

I watched and waited until I made sure the three of them made it inside the shelter. A few blocks away, I pulled the car over to cry. My sobs were just as loud and hard as the thunder and rain pouring outside. I wasn't alone at that moment. I felt His presence. It was clear to me that I was just given a test from Allah! I realized that it was time for me to make some difficult changes.

I thought I could control the direction of my life, but accepting Allah's guidance and submission to His plan was the real destination.

Subhanallah.

The events of that day shook me from my depths of depression I now understood what my existence was for. I needed to be present, to dismantle my past and not focus on the future. Nothing was under my control anymore—but at the same time, nothing was a mistake. I finally realized that there was a master plan.

"

I can now
humbly say
the Quran
is in my heart.

"

sidelemine *46, Kifa, Mauritania*

Growing up in Mauritania was very different from living in America. In America, life moves very fast and everyone runs from one thing to another, always trying to check things off their never-ending to-do list. However, in Mauritania, things move very slowly. When I was a child, we lived in small tents in the middle of the Saharan desert and raised sheep, goats, and camels. We enjoyed each other's company while sipping mint tea. We memorized beautiful poetry and recited it back to each other. Many people think we are strange for living such a simple life, but I loved it. We may not have been traditionally educated like people in America are, but the education of Islam is a deeper education: It is a lifelong process of purifying the heart.

Don't get me wrong; we Mauritanians do believe that a traditional academic education is very important, but our first priority is teaching the lessons of the Quran and the Prophet Muhammad (*PBUH*). When the wife of the Prophet Muhammad was asked about the character of the Prophet, she responded, "Have you not read the Quran? Verily, the character of the Prophet of Allah is the Quran." If the Prophet Muhammad is our role model and the character of our Prophet is the Quran, then the Quran should be the center of our lives. In Mauritania, you find that life revolves around the Quran's more

than six thousand verses and that boys and girls as young as eight years old will have the entire Quran completely memorized.

When I was a young boy, we would go out into the desert and recite the Quran all day and all night. Our goal was to master this beautiful book, so we would spend hours reflecting on its verses. I love poetry, but the Quran is something no man could have ever written. The beauty, the elegance, and the structure of this holy book will leave you in awe whether you are Muslim or not. I remember when I was twelve, I had to recite the Quran to my teacher, from memory, beginning to end. I did it every day for an entire year straight. I would begin when the sun rose and only finish when the sun set. I can now humbly say the Quran is in my heart, and I spend most of my time teaching young kids in America the beauty of this book. If you ever have spare time, you should open the Quran and reflect on a beauty that my words could never convey.

hazar *27, Fishers, Indiana, USA*

To Allah (*SWT*) we belong and to Him we return.

On September 18, 2017, my family received a phone call: "Your sister has been in an accident. Please come to the hospital right away," which really meant, "Your sister has passed away." On this day, Allah returned a beautiful soul to Him. Fatima Hassuneh, or Fatooma to us, was taken by Allah at the tender age of eighteen, two months before turning nineteen. She already had an outfit picked out for her birthday celebration. In the Quran (Surah Al-Anfal 8:30), Allah says, "They plan and Allah plans. Indeed Allah is the best of planners." The Almighty had declared that Fatooma was not destined for her next birthday.

As human beings, we often find ourselves caught up in the hustle and bustle of life. We forget what truly has value and live as if we will live forever. But Allah is the wisest and most merciful, with compassion that knows no bounds. It is with these very attributes in mind that we acknowledge that Allah has set everything in motion with His infinite knowledge. And it is for this reason that Fatooma was destined to return to her Lord. My family was destined to bear the burden of this test.

Fatooma was the most devout among us, waking up for *Fajr* every day. Often, she took the time to wake up our siblings and her friends. Many times

I would see her repeating prayers. When I asked why she did this, she simply replied, "I don't know when my last prayer is going to be, so I want to pray as if every prayer is the last." She believed wholeheartedly in the religion and the word of Allah, and she was a prime example of how to live with your *Qadr* in mind. She lived and practiced as a proud Muslim.

She was truly a joy, always laughing, and had the kindest heart. She touched the lives of so many people by being herself. In the end, the lives she touched gave back in a way I could never have imagined. All we asked for from our friends and family after her death was prayer, and yet hundreds of people came together to raise 50,000 dollars to build water wells in two villages in Rwanda, Africa, in her name. Fatooma had a passion for helping people from a young age, and she was always involved in the community, from activism to volunteering. Our friends, family, and colleagues have continued her legacy by creating something beautiful that will live on.

The adjustment to the loss of Fatooma has been difficult. She was my baby sister, eight years younger than me, and one of my best friends. My family will continue to be a party of nine. We love her. And we always will. The one thing my family asks is that everyone continue to pray for our baby. May Allah give us patience and reunite us in paradise. May this be what He has decreed in our *Qadr*. Ameen.

lisa *21, Brooklyn, New York, USA*

I was raised in an Italian family. My parents were strict when it came to religion. They signed me up for Catholic school and took me to church every week. I was raised not to ask questions or embrace individuality. This is part of what led me to become an atheist. I grew up with an intense hatred for who I thought God was, and what I thought religion was about.

I didn't transform my thinking until I went to college and started making new friends while doing political work. As a college freshman, I started my college's Students for Justice in Palestine group. It advocated for the Palestinian cause on campus and held events to educate the student body on how issues in Palestine are connected with issues here in the United States. The first faculty member I met when I was getting the club chartered was a nun. She was progressive and kind, and she caused me to rethink my stance on religion. Through campus and citywide political work, I also met many Muslims. Through their actions I saw the connection between Islam and social justice.

At first, I was interested in reading more about a religion that asks people to be kind to one another, to feed the homeless, to be gentle with children, and to be strong when defending your rights. This approach with

children especially interested me because I aspired to be an early childhood educator. Reading about these values cemented a decision in my mind. As Ramadan approached in 2016, I switched from being a nonreligious person to preparing to become Muslim. Over the course of Ramadan, I told my Muslim friends that I wanted to take my *Shahada* soon. We chose a day we would all be free so they could watch me convert. Their support and help through the process was extremely encouraging.

When the day arrived, I was very nervous but motivated to take this next step. After praying *Isha*, the *Imam* announced that someone was going to take their *Shahada* and asked everyone to stay in the prayer area. Everyone was looking around for the person who was converting. I felt shy and tried to hide my face. When the *Imam* called me, I said the *Shahada* in Arabic and English. Then all of the women hugged me, and everyone welcomed me to Islam. The whole mosque was happy; people I didn't even know had tears in their eyes. I was particularly glad when children smiled and hugged me, saying that they were excited to meet a new Muslim.

My non-Muslim friends were understanding, but my parents were not. They did not accept my decision, and we avoid talking about my religious views. They see me as a person who betrayed their culture and heritage. We weren't close to begin with, and our relationship will always be a work in progress.

My favorite moments as a Muslim are those when I am reminded that this was the right choice for me. Whether it is watching Sheikh Omar Suleiman's livestreams or meeting in religious gatherings, I always come away more confident in my beliefs. I believe God is powerful and kind. He will be there for people in need, and will empower us to work for justice. I believe God has given us an important imperative to live life through Islam.

"

I believe God
is powerful and kind.
He will be there
for people in need, and
will empower us
to work for justice.

"

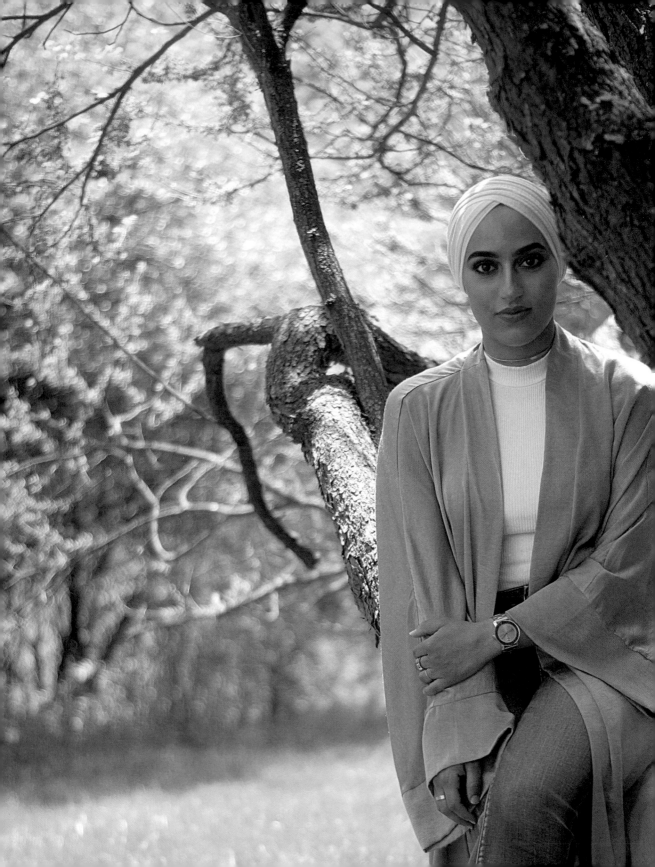

sama *26, Ann Arbor, Michigan, USA*

What is meant for you will reach you even if it is beneath two mountains, and what is not meant for you will never reach you even if it is between your two lips. We have all heard this saying when talking about *Qadr*, or fate. But how can any of us truly believe in fate until we have experienced something that allows us to see the divine hand play its role? It wasn't until my own life flashed before my very eyes—until I took what I thought was my last breath, until I tasted death on the tip of my tongue—that I truly understood the meaning of this phrase.

The night of the accident changed my life. My best friend was driving me home a little past midnight, and we were two minutes away from my house. Turning at the intersection, we got T-boned by another car out of nowhere. I remember my friend screaming, and I quickly turned to look. The last thing I remember seeing was headlights coming straight at us. I learned later we were unconscious for about twenty-five minutes, but when I woke up I had no idea what was going on. We were still in the car when I came to, and all I could think about was the pain stabbing my ribs. My best friend was unconscious and bent over the steering wheel with blood across her face. I tried to stay calm as I called out her name, not sure yet if she was even still alive. I looked to the left, I looked in front of me, I looked to my right—everything was spinning. Though I was trying my hardest to stay alert, I felt myself slowly becoming incoherent. I gave my friend a few nudges to the shoulder, and she regained consciousness, waking up as confused as I was. With my hand applying pressure to the left side of my body where I felt the most pain, I tried to keep myself awake and alert. The last thing I could remember from before the accident was calling my mother to tell her we were driving home and that we were going to make some sandwiches. I remember seeing bright lights everywhere: police lights, ambulance lights, fire truck lights all around. All I could hear were sirens. The bright lights and the loud noise made it much more difficult to focus on trying to understand what the hell was going on. Someone finally opened my door, pulled me onto a stretcher, and put me into the ambulance. I settled into silence and calmness—no tears, no sound, just applying my hand to the left side of my ribcage, knowing my life depended on it.

My best friend and I were separated as soon as we got to the emergency room. I was pulled through the hallways on the stretcher so quickly that

all I can remember is passing lights and doorways. I was taken to the first room available and hooked up to machines. They put needles in my body, and there were doctors all around. I asked what was going on, and how bad it was. There are two kinds of people in this world: the ones who wait around to see "how things go" and the ones like me, who demand to know what is going on at the exact moment it is happening and refuse to take no for an answer. Every time I asked how bad it was, no one answered, so I would grab the next doctor or nurse and ask the same question, over and over until someone answered me. But I was losing every ounce of alertness I had left, and I could barely keep my eyes open; everything was a blur. I remember telling myself to stay calm. Even though my body didn't feel like mine, my brain still did. "Sama, stay awake, stay alert, stay strong. Whatever you do, DO NOT close your eyes." That was all I could tell myself every time I felt the urge to rest.

Finally I got an answer: I had a grade-3 spleen rupture along with five broken ribs and contusions to both lungs. But that still was not enough information for me. I finally grabbed the arm of a female nurse and looked her straight in the eyes and asked, "Am I going to die? If I am, just tell me and cut to the point." She looked back at me and I could tell she wanted to lie, but she just couldn't. She replied, "If you were my daughter, I would want to be here as soon as possible." That's all I needed to know. I looked over at one of the doctors and asked him how much time we had. He didn't answer. I said, "If I'm going to die, just let me know how much time I have left." He took a breath and told me that we were waiting for the surgeon who was on call, and that I had two hours.

"Okay, Sama, two hours is a long time. People fly to another state and back in two hours." That was what I told myself. No matter how bad it got, I had to stay strong because giving up and giving in was not an option. I'd never given up on anything in my life without a fight and I would be damned if I started now. The surgeon had finally arrived, and as soon as the nurses finished giving me the last part of the blood transfusion, we rushed into surgery. The only assurance I got was that the doctors would try their best. As the doctors were getting me out of the room into the hallway, they brought in my parents and my siblings in case this was their final chance to say good-bye. I smiled as I told my parents I would be right out, seeing the tears held back in their eyes. Once in the operating room, I was kept awake during surgery, because the chances were anesthesia would kill me.

Those were the longest two hours of my life. As I lay there, I told myself one thing: If Allah had decreed for my life to end, not a single doctor could save me from that. But if He had written a longer life for me, nothing these doctors would do could mess that up. So I said what I thought might be my final *Shahada* and begged for His forgiveness and mercy. That was the very moment in my life when I truly understood the meaning of submission in Islam, of submitting to Allah, to His will, and to His decree. I recall my breaths slowing down and my eyes beginning to close. I looked at the doctor, and we both knew I couldn't hold myself together anymore. Whatever strength I had left drained out along with the blood that was coming from my spleen. The doctor looked at me and said we were doing this together; he was doing his part to stop the bleeding, but I had to do my part and stay alive. In my mind, I felt a sense of comfort as I took all the weight onto my shoulders. I trusted the One who gave me life, knowing He was the same One who could take it away. The act of having complete trust in God at these moments made my worries disappear. I saw the last bit of light before I closed my eyes and prepared to meet the One. That was it, twenty-four years ending just like that, like a brief dream. Every fight, every struggle, every heartbreak experienced, every tear I shed in the time I was in this world meant nothing. It had all seemed fake, like it had never even happened. Death was the end of this world, but the start of the other. As I called out God's name, I began to breathe again and to open my eyes. I was still here.

Though I lived in body, my soul died that night, or maybe it was simply reborn. I never again saw this world the same as I did before. The chances of me surviving that night were close to impossible. But that was His plan. I still have a long process of recovering ahead, but I now live every day like a traveler in this world crossing over a bridge, waiting to return to our creator. Everything I see in this world, I easily see through and look past. I was lucky enough to be given a second chance.

refugees

When we first embarked on our "Muslims
of the World" journey, we, like most
people, had our own preconceived notions
of refugees and how their tales should
be told. We assumed their stories would all
be about injustice, heartbreak, homes
no longer standing, or futures uncertain.
But what we found by listening to these
refugees tell their stories in their own words
is that they are ordinary people who have
been placed in extraordinary circumstances.

It was through these conversations that our eyes were opened, not only to the horrors of their realities, but also to the fact that the things they held most dear—safety, family, shelter, education, hope—are in fact the same things cherished by anyone living anywhere in the world.

Any person who has been forced to leave their country to escape war, persecution, or a natural disaster is a refugee. Even the first settlers to the United States, who came to the New World to flee religious and political persecution in Great Britain, were refugees.

There is an Arab proverb that states, "If a nation one day decides to be free, then there is no doubt that destiny will answer. And there is no doubt that eventually the night will end, and there is no doubt that eventually the chains will be broken." These are words full of hope for those people who live under a cloud of darkness and fear, people who feel they have no way to escape the dangers of their own homeland. Syria, Afghanistan, and South Sudan are only a few of the countless countries in which people have lived with and through political strife, persecution, or unimaginable disasters. A 2016 report from the United Nations Refugee Agency confirms that 65.6 million people are currently living as refugees or displaced persons within the borders of their own countries. The number of displaced individuals around the world today is the highest it has been since World War II. At the end of that global conflict, there were some 11 million refugees in Germany. But today's conflict in Syria has alone displaced at least 12 million people and counting. They are victims of war crimes such as murder, torture, rape, and chemical weapons attacks. Militants blocking access to food, water, and health services have led to a humanitarian crisis in which 70 percent of Syrians lack access to water and four out of five of these people live in poverty.

In 2015, more than 1,011,700 migrants from around the globe arrived in Europe by sea and almost 34,900 by land, primarily through Turkey and Albania. But in 2017, the Trump administration reduced the number of refugees permitted to enter the United States from 110,000 to 50,000 per year. Those that were turned away, primarily women and children, were forced back into danger and displacement. Various attempts by the Trump administration to ban travelers originating from certain countries led to impossible circumstances for many individuals separated from loved ones. This resulted in Syrian refugees, who are facing a crisis of unimaginable proportions, being suspended indefinitely from entering the United States—all because of prejudice and

suspicion. These measures only work to legitimize the harmful and inaccurate stereotype that all Muslims are terrorists and lead to often violent backlash against the American-Muslim community.

Yet this harmful political move has one silver lining: It has brought together people from all different backgrounds who share a common goal of compassion and acceptance for all, and who stood up for that goal in mass protests against the Muslim ban in airports across the country. Actions taken because of a sense of responsibility for our fellow human beings are changing the course of American history and continue to challenge immigration bans that attempt to make the victims of war and genocide someone else's "problem."

—Sajjad Shah and Iman Mahoui

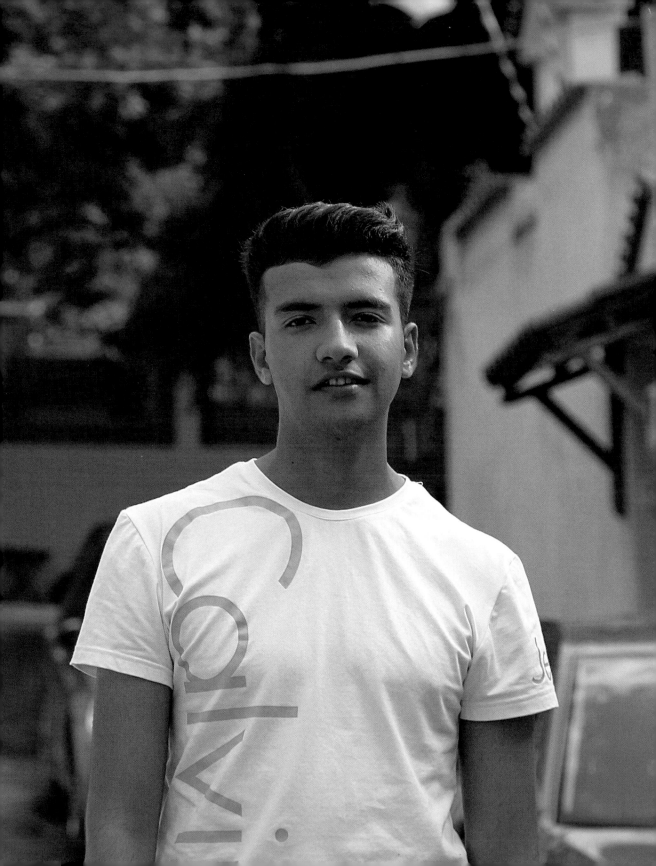

khalid *15, Athens, Greece*

My life in Afghanistan was amazing. My father was a doctor and my mother was a dentist. My family also owned three companies that sold windows, clothing, and a variety of other items. But one day, a shipment of goods was confiscated by the Taliban. As a result, our businesses failed shortly thereafter. My uncle, who was an engineer and worked for a foreign NGO, was stopped and killed by the Taliban on his way to work.

Then, when I was seven or eight, my father went on a business trip to another city in Afghanistan. We received a call from my father's friend saying that he was murdered. To this day, we aren't sure who killed him or why. After my father's death, everything started to change. Random men started coming to our home to give my mother warnings. One day, as she was walking home from work, a stranger approached my mother and said, "If you don't leave, we will kill you just like we did your brother and husband."

Faced with the threat of death, my mother made the decision to move the family from Afghanistan. We were a group of twelve: my mother, brother, sister, grandmother, four aunts, three cousins, and me. Together, we made the journey from Afghanistan to Greece. It was a one- and- a- half- month trek that took us through Iran and Turkey. It was a dangerous trip, as we were under constant threat of fire in Afghanistan and Iran. We were shot at twice at the border of Iran and Turkey. We traveled by sea from Turkey to Greece. We paid 2,000 euros to travel alone by rubber boat. We left at two or three in the morning. It was pitch black outside. The journey lasted twenty-five to thirty minutes, but it felt like hours. I was terrified that I was going to drown. I lost all hope. I was sure that I would die that night. "If I die, I will die," I kept telling myself. I would be lucky to make it to the other side.

We reached Lesbos that night. From our arrival at 4 A.M. until 8 A.M. we were stranded at the bottom of a mountain with no idea of where we were heading. Finally, we were led to a small city. The people there called the police and we were taken to a refugee camp. The situation was horrible. There was no room for us. We had to stay in a tent for a week. My grandmother became ill, and then they moved us to a family camp. It was better there. There weren't any fights between the residents, and everything was calmer. We stayed there for ten months.

After that, we were relocated to Athens. Life in Athens is much better than in the camp. We have an apartment, we're comfortable. I'm enrolled in

a Greek school, and I am enjoying learning the language. But I want to leave Greece. We want to move to Canada and join family we have there. We are not happy in Greece. My cousin and sister are not allowed to go to school. The school was afraid they were going to wear *hijabs*, which is not allowed. The truth is that they don't wear *hijabs*, but the school assumed they did because my mother does.

Although I'm young and have experienced a lot of trauma, I will never lose hope again. Life is like a game. Sometimes you lose, and sometimes you win. Someone who never loses hope can do anything he wants. My dream is to one day become a pilot. I want to travel the world. I know that if I don't lose my hope and stay true to myself, I will find my way. I will pursue a life of happiness and success.

mahmoud *27, Amman, Jordan*

I was an activist against the Syrian regime at my college in Homs. I was in the process of building a better future for myself but things didn't work out as I expected. I was in my third year of school when I was listed as "Wanted." My parents lived a few hours away, and I had to leave the country so quickly that I wasn't able to say good-bye to them.

When I arrived in Jordan it was hard to find a job. I was not there legally and no one would hire me. I was getting desperate. I only had ten dollars left in my pocket. But God helped me in some unexpected ways. A friend whom I hadn't talked to in ages called me out of the blue. She said she was sure I needed some money, and sent me some. Another friend called me about a job opportunity in Saudi Arabia. I was able to work in Saudi and save money so I could return to Jordan and continue my education. I eventually finished my degree in mechanical engineering, but by the time I was finished, I once again was down to my last few dollars. All of my friends were getting ready for graduation day. All I could think about was how poor I was. As I was getting ready to head to the ceremony, a friend came over and said, "You need this," and handed me an envelope full of money. I was so desperate I didn't argue with him. I know how blessed I was. I was able to come back to Jordan

to a safe place, go to school, and work. Now it was time for me to give back. I started volunteering in a center that supports women who have been sexually assaulted. I remember one woman who was disowned by her family after she was raped. She died a few years later. She was so depressed she couldn't live.

Every morning I wake up knowing it is my duty to change lives for the better. When I sit and talk with a woman, or play with her children, I can see my family and friends in their eyes. I can see the home that I have been away from for six years. It reminds me that we Syrians have to look out for each other. If we don't support each other, who will?

medhat *30, Berlin, Germany*

I was born in the city of Suwayda, Syria, on September 20, 1987. I completed my studies in the field of prosthetics in 2007, but after that I decided to turn to the Higher Institute of Dramatic Arts to study dance. In the dance department, a shift began within me, one that would change my entire perspective on the world around me. The art world had always been a mystery to me, but it's where I realized my true purpose. When I began my journey into the world of dance, I was part of a community that did not accept the idea of male dancers. Even though people looked down on me, I remained at the institute until I received my diploma in the field of dance. My body and soul had found the perfect environment to truly express my thoughts and my feelings.

I wanted to travel around the world and share my artistic message with people. But the war in Syria pushed those dreams aside, and I began to hope to simply stay alive. Toward the end of my school year, my dream of travel became a means of survival. But I came from a poor family, and we did not have the kind of money needed to reach the European Union.

On a sunny day in June, very quickly, an opportunity arose and I made the decision to flee. I started my journey with the determination to live a better life or to die trying. A year after leaving my home I reached Berlin. Within

the first few minutes of my arrival, the positivity and the energy of the city was running through my veins. People were chanting, "Stay! I am your new country." That was when my life changed in ways I never could have imagined.

By accident, I came across the office of the world-class choreographer Sasha Waltz. I decided to take a chance and walk in. I was shocked when the people there welcomed me with open arms. I made an odd request: "Can I dance with your company?" Shortly after, I met Sasha herself, and she instantly liked my ideas and offered to help me start my own project, called *Amal*.

The show was a big hit, and European audiences loved it. I was able to say that the better life I had always hoped for was becoming a reality. The doors in the field of dance, once closed to me, started to open, and I was able to work with different choreographers and dancers from all around the world. I established a dance group of Syrian refugees in Germany, and we currently have five professional dancers who perform shows in different parts of Europe. We want to share our love for the arts while spreading awareness of the refugee crisis to anyone willing to watch us dance.

sana'a *32, Amman, Jordan*

A few months ago, my brother accidentally hit a little girl named Samah with his car. We took her to the hospital and she was released the same day. We went to visit Samah at her house a few days later. We had gifts for her, and we wanted to see how she was doing. I noticed her family was extremely poor. During *Eid*, Samah's family came to visit us. This time I had questions for Samah's mom. The family was Syrian, and I know that each Syrian family has a story to tell. Samah's mother told us how precious her daughter was, that she was unique and her most beloved child. Then she told us about a horrifying tragedy.

About five years ago, when Samah's family was fleeing the war in Syria, about thirty members of their family went to a farm far away from the war zone. They stayed there for few days, but then the regime got closer, and they were in danger again. On a very cold morning, right before sunrise, the whole family left the farm and packed themselves into their two cars. People were stacked on top of one another, covered with jackets and blankets. Samah's mother made sure all her children were in the car before she jumped in and the car took off.

A few hours later they arrived at their destination. The adults started looking for their children. Samah's mother found all of her children except for

one. Samah was missing. The family looked everywhere for her, but the only place left was the farm they had just fled. When they got in the car to go back to the farm, they moved the blankets and found Samah underneath. She had been packed between so many people that she suffocated and died.

I was shocked by this story, and then I asked Samah's mother, "Who did my brother hit with his car?" She smiled, and said that her family was lucky to be alive, and must keep giving life. She said that she got pregnant a few months later, and she called her new daughter Samah to honor the memory of the daughter she lost. "If we give up, then death will win. We face death by bringing new life," she told me.

rafal *39, Hackensack, New Jersey, USA*

We were happy in Iraq. My husband worked as an accountant, and I was a housewife making sure my children received the best possible care and education. My parents used to live near me. My husband and I built ourselves a small, happy family. In 2003, after war broke out, things changed dramatically. My husband lost his job, so he began to work with a company that did business with the United States. As a result, unknown Iraqi groups threatened to kill him several times. We were terrified. For years we could not move anywhere else. We were stuck in Iraq dealing with both death threats and an ongoing war. Thoughts of my children kept me awake at night: What if something happens to their father? Or me? Where will they go?

My husband decided it was time to leave. We packed our things and arrived in the United States via the American Embassy. It felt like freedom the minute we arrived. It was a great feeling, but it didn't last long. The program that hosted us gave us a house for six months, but we had to complete a lot of paperwork during that time in order to keep living there.

I didn't know any English. My husband barely knows English, and my children did not learn English well in Iraq. We could not complete the paperwork we were given. After six months passed, we were thrown into the streets

with the little furniture and clothing we had. I was desperate. It was cold. We were a family of five that had no place to go. My two sons were able to sleep at friends' houses. My husband, my daughter, and I stayed at a cheap hotel for a few days, then in a friend's basement for two months. My husband was angry, and he felt ashamed of not being able to provide for his family. He got a job, but that did not last long. He was sick and any job that required mobility was impossible for him to keep. Finally, a lawyer I knew came to the rescue and helped with the paperwork. We got a house and food stamps. We felt like human beings again.

I miss Iraq, but life here is safe. I am not worried about my sons being kidnapped by some militia, or my husband being shot. It's a hard, daily struggle to provide for my children in such an expensive country, but they are worth it. I cook, clean, homeschool, anything to make my children happy and give them their basic needs. I am now learning English and planning to go back to school. People are kind to us. Everyone is trying to help, and I am grateful I am so lucky. But I'm also sad and worried for the hundreds of thousands of people who still live in fear every day back in Iraq.

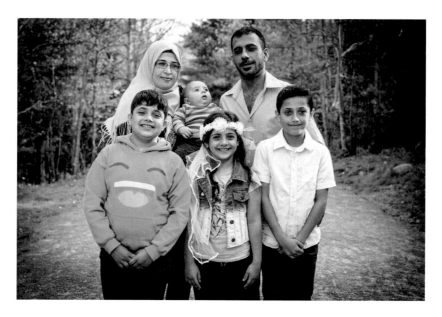

wael *35, Halifax, Nova Scotia, Canada*

I was destined not to have a normal life in the town of Al-Harra in Syria, where I was born. My only friends were Kasem and his sister, Rana. We all had one major thing in common: We were born deaf. We used to spend our time together playing and sometimes fighting (but never for long). This all changed when their mother died. Rana was nine years old, and she cried hopelessly. Kasem and Rana moved to another city to live with another family member for some time. Just like that my two friends disappeared from my life. To combat my loneliness, I started working with my dad. I became an expert at installing and fixing tiles. My body became strong, but my heart was empty.

 Ten years later, I saw Rana walking nearby. My heart was racing but I didn't have the courage to walk up to her and say hello. I went to my dad, and I only had one thing to say: "She's the one, I swear!" He was hesitant at first, since love that comes so quickly is hard to believe for most, but he finally accepted that I was serious. We got married and were blessed with three deaf children and one hearing child. But then the war started and our joy was stolen. Things kept getting worse, and escape became our only solution. We walked for five days until we reached Amman. We spent two years floating around UN camps then a golden opportunity arose: a chance to settle in Canada.

People are nice here, and we have a place to call home, but there are many obstacles that are hard to overcome. Sign language is different, and snow is the norm. My kids don't have friends here, and at first I had no job. We had and still have reasons to despair, but patience and faith have provided us with what we need to transform. It has been a year now, and things are better. I am now employed, and my kids can write every English letter. I am a refugee who cannot hear, but how can I not be thankful for God's abundance of blessings? I've learned to remain optimistic and be content with what I'm given.

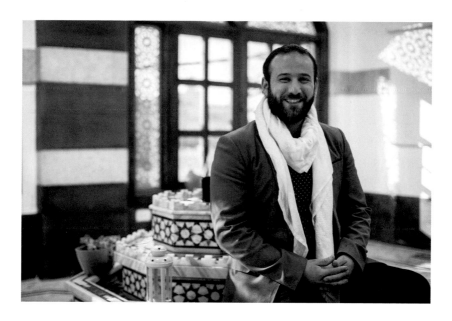

wesam *31, Amman, Jordan*

I was born into a wealthy family in Syria, but when I was twelve my dad lost his business, and I was forced to start working. I was very creative about finding ways to make money. We had a PlayStation. I took the TV and the PlayStation out to the street and let neighborhood kids pay to play it. I rented out my soccer ball. I used to love to eat cactus, so I started selling it. Despite the difficulties, I was able to go to college and graduate. I started my humble career conducting business training that required me to move to Jordan. Three years later, war broke out in Syria. I saw all of the blood and death on TV. My family fled and came to Jordan to stay with me. We were about twenty-five people in just two bedrooms, but it didn't matter. What mattered was that my family was safe.

A friend sent me a message asking me to give my workshops to people in Syria. I thought he was insane at first. Why would people need business training in the middle of the war? But after seeing the severe issues that people were dealing with in Syria, I felt that despite the dangerous conditions, I needed to help them. It may sound crazy to leave peace to travel to a war zone, but the people of Syria were dear to my heart as these were my brothers and sisters in Islam. Therefore, I agreed to go. Before I left, my parents were hugging me like it was the last time they would see me. My children were crying

69

"

Maybe, if
we teach
our children
how to
build rather
than
destroy, all
of these wars
and crimes
might
someday stop.

"

and my wife was afraid. The border between Syria and Jordan was impossible to cross. I went to Turkey and drove for four days before I finally arrived in Syria. I was almost shot and killed three times, as it was illegal to drive in the area we were crossing. I finally got to Duma, where my friend lived. The next morning at 9:00 A.M. we were all sleeping when I heard a huge explosion. I started running around like a crazy person, waking everyone up and telling them to get dressed and run away. My friend opened one of his eyes as he was lying in bed and said, "What's wrong with you?" I told him there was an explosion nearby and we were going to die. He just laughed and went back to sleep. I think death had become something they didn't fear anymore. They had gotten used to it.

I taught about seventy Syrian men how to build small business concepts. I focused on concepts such as business development, accounting, and long-term sustainability of organizations. We started with that many people. As the days passed though, people went missing. "Where is Amer? Where are Salem and Mohammad?" The answer was simple: "A bullet, a bomb, an explosion, etc." Death came swiftly. People were being killed on a daily, even hourly, basis.

One day, we were asked to help a nearby family. Their house had been bombed. When I walked into the living room I saw a father hugging a young girl who lay dead on the ground. The military had bombed a house with nine children playing near it, and they were all killed. I was in shock. I instantly thought of my children, who were blessed to not face the war, while children in Syria die so easily. I went back to Jordan heartbroken. I had seen my people dying, and I had no idea how to help. My children are growing up. They have never seen Syria, yet they know what happens to our people there. We might be refugees, but we are still humans. We belong to the whole world. I will teach my children that they are from Syria and Jordan, and they must work to build a better future for all of humanity. Maybe, if we teach our children how to build rather than destroy, all of these wars and crimes might someday stop.

mohammed *27, Amman, Jordan*

Back when I lived in Gaza, a friend recommended I watch the movie *District B13*, which inspired me to get involved in the world of parkour. The film spoke to me so much that I decided to dedicate myself to learning all about this form of obstacle-based physical training. I was using YouTube tutorials to help me practice, and on day three I broke my leg. It was a few months before I was able to walk on it normally again. While I was healing, I searched for people who wanted to practice parkour with me when I was better.

We all improved as we practiced together. Eventually we decided to hold an event. People were excited to see what parkour was all about, and we sold twelve hundred tickets in a week. Unfortunately, the event was shut down by the government right before it was supposed to start. We were fined 10,000 dollars for not having the right permits. My team left me and I was in debt; it was a miserable situation. I started practicing in a space that my uncle owned. I began charging other guys ten dollars a month to practice there, too. In 2011, the building was demolished by an Israeli airstrike. I was back to square one.

I kept working hard to pay off my debt. I started selling falafel in a small shop. I had no money, so I slept behind the refrigerator in the shop. I can still remember the sounds that refrigerator made. In front of the shop there

"

We were torn
between
love for our
people and our
home, and
a desire to build
a future
brighter than
the ruins of our
homeland.

was a small park. During my breaks I would go there and teach people parkour. We started sharing what we were doing on social media—suddenly we were getting requests for interviews! Everyone in Gaza was talking about us. It was like we were stars.

In 2014, war broke out again and hundreds died. To bring a little bit of joy to people's hearts, we started something called "parkour on the ruins." We were trying to prove that we were alive and loved life despite all of the destruction. We decided to organize another event. This time we didn't sell twelve hundred tickets; we sold more than ten thousand.

But now I had even bigger goals in mind. I had a student named Mohammad, and he was one of the best I had ever seen. I had faith that Mohammad had the potential to make history, so I signed up the entire parkour team for that year's *Arabs Got Talent*. My dream was to see Mohammad break a Guinness World Record, but people continued to underestimate our abilities. They told me there was no way a guy from Gaza could break any world record.

It was a tense time. Our preparations for *Arabs Got Talent* were stalled when we all had to flee Gaza because of the war, but upon arriving at the border of Egypt as refugees, we were told the border was closed. We slept for several days along the Egyptian border; we could not go home, so we spent our time on the border practicing. Finally the border opened after months of waiting, and we took a bus for sixteen hours from the border to Cairo's airport. From there we headed straight for Beirut, Lebanon, where we would go on to perform on *Arabs Got Talent*.

In 2017, after fleeing our war-torn country and competing in an international competition, Mohammad broke a Guinness Record. It was what we had worked so desperately for over the past eight years. A lot of us never returned to Gaza; we couldn't. We were scared of being trapped there again. We were torn between love for our people and our home, and a desire to build a future brighter than the ruins of our homeland.

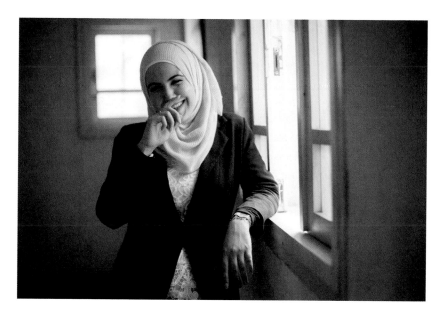

lubna *23, Amman, Jordan*

It was forbidden in my culture for a girl to travel alone. But when you are a refugee, your choices are limited. My dad lost his life savings when his shop and house were destroyed because of the war in Syria, so my parents left the country and settled in Saudi Arabia. Due to our financial status, I had to leave them and go alone to Jordan for college. My dad hugged me and told me to be strong, to focus on my studies, to stay away from trouble, and that he couldn't wait to see me graduate. I knew that my dad hated the fact that he was forced to send me out on my own.

I traveled by bus, and when I got to college, I moved into a dorm with girls from different backgrounds. Two weeks after I arrived, I was texting with my cousins when one of them wrote, "I'm sorry Lubna. We loved your dad so much." My heart suddenly stopped beating. "What's going Ann?" I wrote frantically on the chat app, my spelling all wrong. No one answered my message. My mom called a few minutes later. She told me my dad had passed away. I started screaming. I was alone in my room in a strange country with no one there to comfort me.

A friend bought a plane ticket for me, and I flew to Saudi. It's ironic that this was the first time I had ever flown on a plane. I had always imagined myself flying home after getting my degree, traveling to hug my dad and show

"

Being
Syrian today
is a curse.
No one wants
us. But we
are fighters,
and we plant
hope as
we walk
through life.

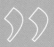

him how successful his daughter was. When I arrived after my father's death, I did hug him, but he couldn't hug me back.

Again, what I loved was taken from me. First my homeland, and now my dad. He had suffered a heart attack, which we attributed to high stress after he had been fired from his job. I had no money to go to college, and due to our refugee status, we were barred from traveling to any other countries. My family was left all alone, with no viable options.

It's scary how a human being can just exist on two pieces of paper: birth and death certificates. I held these two papers and asked my college to support me. They offered me 75 percent off my tuition so my dream of becoming a pharmacist could become real. When I graduated, I had huge dreams. I wanted my mom to stop working twelve-hour days for low pay. I wanted my brother to finish his education. I wanted to save money and own a shop just like the one Dad lost. Being Syrian today is a curse. No one wants us. But we are fighters, and we plant hope as we walk through life.

sarah *25, Berlin, Germany*

I am twenty-five years old, and I was born and raised in Germany, although I am of Algerian descent. My religion and my faith are very important to me, and I try to practice the values of Islam to the best of my ability. Everyone has their own interpretation of this religion. To me, Islam is primarily a religion of love, respect, kindness, charity, and gratitude. As it does in many other faiths, charity plays a big role in Islam. I know I was lucky to have grown up with both of my parents in my life. I went to school and later to university without having to worry about having food to eat or being safe. This has driven me to help those who weren't as lucky as I have been.

In August 2015, my life changed. I was sitting on my couch, checking my Facebook feed, when I saw a post about a refugee shelter that had opened up not too far away from our house. I decided I would go there the next day to see if I could help. I knew that many refugees were from Syria and spoke Arabic, which meant I could use my Arabic speaking background to intimately connect with them. When I arrived at the shelter I wasn't sure what to do. I found someone who looked official and said, "Hi, I'm Sarah. This is my first time volunteering. Maybe I could translate, because I speak Arabic." He immediately took me to translate for someone from Libya . . . then Syria, Iraq,

Morocco, and Tunisia. I arrived at 10 A.M. and thought I would stay for just a few hours, but I left ten hours later. The next day I woke up early and told my parents I needed to go back, because these people needed me. I headed straight to the shelter. All the volunteers tried their best, even though most of us had no experience and were becoming increasingly emotional about the situation we found the refugees around us facing. I decided I would volunteer regularly as a translator at the shelter. I also created a room for the children, hoping they would be able to play and find solace among the chaos.

After my first day volunteering, my outlook on life changed. The next time I used Facebook it wasn't to watch cooking videos, but to write a post searching for people who spoke Arabic, Farsi, Russian, Pashto, etc. The response was overwhelming; so many people came to help. I was so happy and grateful to everyone who showed up after reading my post. I realized I had a new responsibility, to organize all the people that came. I was a little bit afraid because I had never "managed" a big team before, but I knew that no matter how scared I was, the men, women, and children at these refugee camps were terrified for their lives.

For two years, I spent every day at refugee camps in Berlin. The times I had there were the best and most challenging experiences of my life. My parents and friends started volunteering, and every day became a challenge for me to do better and more than the day before. After finishing my bachelor's degree in international communications and translation, I started working for a big company, but I was happier when I was a volunteer. I miss work that fulfills me. I miss going to bed knowing I have helped at least one person. I miss seeing the smiles of the people I helped. I'm not going to stay at this job forever. I would rather earn less money and do the work I love, and help people as much as I can.

I learned more when I was a volunteer than any other period in my life, and I had more experiences than I could ever buy. I met so many people. I could write a book about this special time in my life! I encourage every person to do something for people in need. Go out into your neighborhood and find an opportunity to volunteer, even if it's just one hour per month. We spend so much time on the internet, watching YouTube or Netflix, when we could be using that time differently. There is so much negativity in this world, and so much negativity in the media and in Western society toward Muslims. It is the responsibility of every Muslim to go out and show humanity that Islam is a religion of love, kindness, and charity.

racism and prejudice

*We declare our right on this earth . . . to be a
human being, to be respected as a human being, to be
given the rights of a human being in this society,
on this earth, in this day, which we intend to bring
into existence by any means necessary.*

—Malcolm X

In Islam, all of humanity is equal in the
eyes of God. Righteousness and good
actions are the only qualities that make
someone virtuous, not their race, skin
color, lineage, or nationality.

The teachings of the Holy Prophet counter bigotry and serve as a model for coexistence. The goal of Islam is to live in peace with people of all religions. In the above Quran verse, God commands Muslims to believe in all the holy books revealed by Him and to respect all others' beliefs.

After Malcolm X, one of the most influential activists of our time, performed *hajj*, the Islamic pilgrimage to Mecca, he reflected on the Prophet's insistence on harmony. In a long-lost letter only recently discovered, Malcolm X wrote home to family and friends after his first trip to Mecca in 1964:

> *I could look into their [Muslims'] blue eyes and see that they regarded me as the same . . . because their faith in One God . . . had actually removed "white" from their mind, which automatically changed their attitude and their behavior toward people of other colors. Their belief in the Oneness has made them so different from American whites that their colors played no part in my mind in my dealing with them. If only white Americans could accept the Oneness of Men, and cease to measure others always in terms of their "difference in color."*

But racism still plagues our society today and divides us. It breeds hatred, creates conflict, and causes countless people to suffer. The Black Lives Matter movement, like all other historical movements that aim to change the world, began with a vision for a better reality. African American Muslims make up 20 percent of the Muslim population in the United States alone, not to mention the even larger percentage of black Muslims worldwide. Muslims of the World stands with and for African American people, regardless of their beliefs. We also stand with Muslim people of color who face the threat of both racism and Islamophobia. Recognizing the importance of the Black Lives Matter movement makes possible a united front against racism. It reminds us that we all come from one mother or father. We may differ in skin color or native tongue, but one thing is certain: We are all equal. Ali, the son-in-law of the Holy Prophet, said it beautifully: "A person is either your brother in faith, or your equal in humanity."

—*Sajjad Shah and Iman Mahoui*

A person
is either your
brother in
faith, or your
equal
in humanity.

—*Ali ibn Abi Talib*

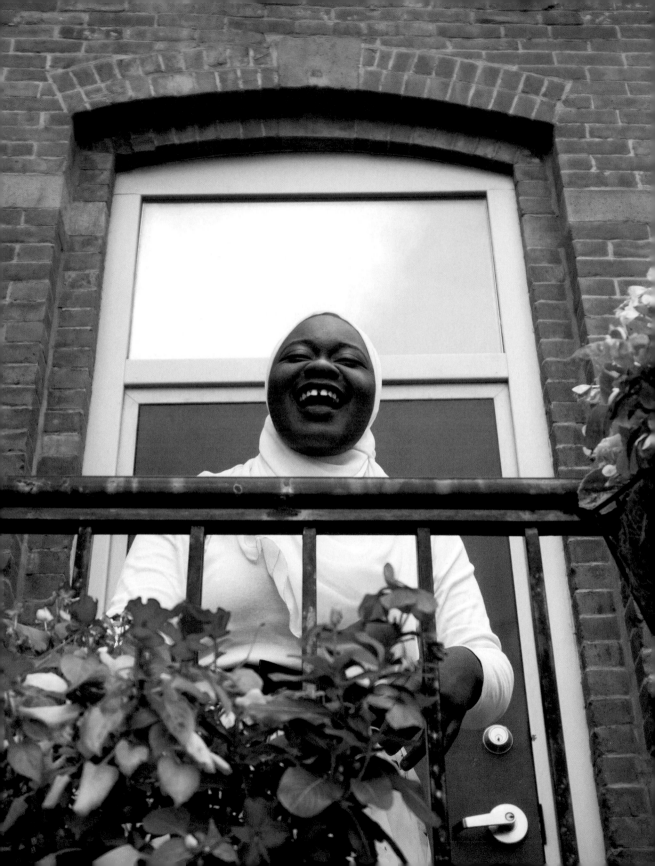

nadirah *21, Orange, New Jersey, USA*

Muslim. Woman. Black. I'm a "triple threat." The identity groups I belong to have greatly influenced the experiences I've had in my life. They've altered how others perceive me and how they treat me, as well as how I perceive myself and others like me. It's been a struggle, a constant push and pull between myself and different members of society.

Before accepting myself for everything I am (and everything I am not), I tried to assimilate within other groups. I desperately tried to fit into spaces that weren't built for me. I tried being "more Arab," hoping that the Muslim community would accept me. I tried being "more ladylike," speaking more quietly, only saying positive things, and being more docile in order to be accepted by men. I tried being "less black," ignoring the implicit forms of racism in public settings, and hoping that I wouldn't be labeled an "angry black woman." I tried "quieting" my Islam, never speaking about it unless asked, wearing a fashionable *hijab* and hoping I wouldn't be labeled a terrorist. I tried my hardest to be the opposite of everything I was. I tried to silence my true essence so that I would be loved, desired, and accepted. But when I began to apologize for who I was, I felt ashamed.

When I think about my struggles with identity, I remember what it was like to attend a predominantly Arab and *desi* middle school. That's where I first became aware of how negatively people perceived me. I straightened my hair, tried to speak like them, listened to their music, ate their food, and dressed like them. I replaced my culture with theirs, with the hope of being seen as one of them. But it didn't matter. I was still taunted for my big nose, my fleshy lips, my coarse hair, my urban vernacular, and everything else about my blackness. And because I was black and Muslim, it was assumed that I didn't practice the same way as they did, or that I didn't love Allah (SWT).

I clearly recall the pain, the shame, and the tears, even though they dried long ago. I remember the stress, the pressure, and the anxiety, and I still have the scars. Even though I'm happy to say I've become unapologetic about being a black Muslim woman, I'll never forget how hard this journey was for me.

I tried to alter parts of myself to make others more comfortable with who I am: a young Caribbean American, Muslim woman who is fat, dark, loud, and passionate. Rate of success: zero. None of it worked, not even a little bit.

No matter how much I tried to change, my true self showed through, even brighter than before.

To any beauties struggling to find the calm in the storm: You are black, you are Muslim, you are a woman, and if you see another day, find the blessing in all you are, because none of that is going to change. Hold no shame in your titles. Be unapologetic! Be bold! Be amazing! Be black! Be loud! Be a woman! Thank Allah, again, again, again, and again!

"

Before accepting
myself for
everything I am
(and everything
I am not), I tried
to assimilate
within other
groups. I desperately
tried to fit into
spaces that weren't
built for me.

"

"

I have met many
people who live
in a bubble
where racism and
discrimination
grow. But traveling
opened my eyes
to a new world.

"

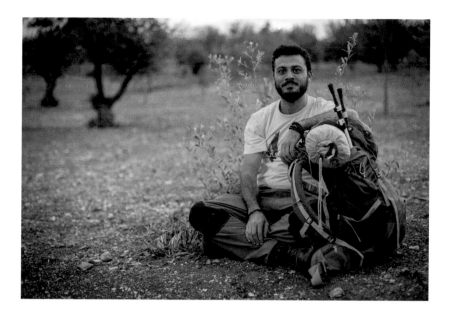

motasem *27, Amman, Jordan*

I went to college in Jordan and went back to Palestine after I graduated. At the border, Israeli soldiers took me and held me as a prisoner for two months. I was innocent of everything they accused me of, so I was eventually released with no charges. I was not allowed to travel outside of the country for a while, so I decided to tour Palestine. Politics is all most people know about Palestine. The media only shows the war, so few people know what a beautiful country it is. I packed a backpack and headed to the mountains of Palestine. I visited Nablus, Khalil, and Hebron and snuck into Jaffa, Haifa, and other cities most Palestinians are not allowed to see. I documented everything. I took pictures and posted things on social media. I was thrilled to see new places and meet new people.

When I was eventually allowed to travel outside of the country again, I quit my job and started living my dream of traveling the world. I have met many people who live in a bubble where racism and discrimination grow. But traveling opened my eyes to a new world. I slept above the clouds in Nepal and walked with barefoot locals in Zanzibar. I met a Ukrainian woman whose dad was a supporter of the Palestinian cause, and I had lunch with tribes in Morocco. I climbed Mount Kilimanjaro and smelled the freshest air there is.

When you experience all of this, it's hard to see the world the same way. You realize how much there is to discover. You learn how rich our planet is, and while you alone are small, your impact can be large. Racism fades when you travel, and humanity flourishes.

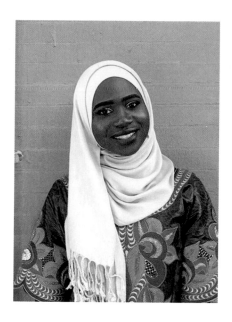

mariyamou *21, Bronx, New York, USA*

I remember the first time that a South Asian friend of mine used the N-word. Actually, there were many "first times" because with each utterance of the word, I remember the discomfort that followed, and how quickly I moved the conversation along. I just didn't want to deal with what it all meant. I didn't want to confront the reality of a South Asian Muslim man using the N-word in front of his black Muslim friend and what that meant about our relationship and the broader dynamics of Blackness within the Muslim community.

I was not in the habit of calling people out—partly because I tried to avoid confrontation, but also because I was afraid to feed into the stereotype of being an "angry black woman," especially in a Muslim space where my "Muslimness" is constantly questioned because of the color of my skin. Our community is still baffled when they encounter a black Muslim *Hafizah* or those whose Arabic "is so perfect *Mashaallah*," because we live in a society where Blackness is equated to less than. As black people, we are told we are not smart enough, that we don't try hard enough, that we are just not Muslim enough. So as a young woman still molding her identity and longing for a space in her community, I didn't want to create tension and sever relationships. I felt that I had to be the black Muslim girl who was present enough to be tokenized but

submissive enough to not make too much noise, or ruffle too many feathers. And I did that for a long time. I sat silent as I heard the N-word being used left and right by my South Asian and Arab Muslim "friends." It came to a point, however, where I could no longer turn a deaf ear. I had heard too many uses of the N-word by non-black Muslims, and I had had enough.

I finally mustered the courage to say something to my South Asian friend. For so long, I had made excuses for him and people like him about how it was okay for them to use the word if they grew up in the "hood." I didn't realize the lies of complacency that I was telling myself in order to maintain my sense of having a "safe space" in the community. But how could the community be a sanctuary for me when my feelings and experiences were denied by those who are meant to be my brothers and sisters in Islam? I expressed to my friend in countless conversations how the word made me and others around me feel. I described the history of the word and how his residence in an urban setting did not justify his use of it. Simply put, I wanted to shout, "YOU ARE NOT BLACK." I could feel myself almost pleading with him, trying to get him to understand. I wanted to shake him, to make him realize how his apathy deeply hurt me and made me feel invisible as a black Muslim woman.

People don't realize how exhausting it is dealing with the realities of being black in America and—as if that isn't enough—having to constantly explain your experiences to others in order to feel validated. It's tiring. I shouldn't have to put myself in a vulnerable place to get people to empathize and to understand that my struggles are real, yet I am constantly made to do so.

The use of the N-word is an issue that has not been completely addressed within the Muslim community. For so long, I couldn't find courage to address it face on; my internalization of the stereotypes surrounding my black femaleness held me back. Yet I also knew my silence did nothing to help the matter. And so after years of racist trauma within Muslim spaces and months of critical reflection, I finally wrote a Facebook post to the community:

> *Using the N-word is not okay. Whether it be in conversation with friends, singing along to song lyrics, or use in hashtags. If you are not black, you have no right/are not entitled to use the term.*

> *It's not cool, cute, or funny in any way. The fact that non-black folks think they can use the N-word as if it has no impact on their black "friends" goes to show the level of ignorance that still exists within those communities.*

"

I was afraid to
feed into the
stereotype of being
an 'angry
black woman,'
especially in a
Muslim space where
my Muslimness
is constantly
questioned because
of the color of
my skin.

"

“

I affirmed
my own pain and
experiences
by speaking up
and making
it known that
I do exist and
that I will
not be silenced.

More importantly, y'all fellow South Asian and Arab folk need to call each other out when it happens. It's not enough to say, "at least I don't use it," but then sit silent when you witness your friends doing so—you are equally responsible for allowing it to become a norm in the Arab/South Asian communities.

We can't preach antiracism within the Muslim community if this continues to be an issue. Words matter, and they speak volumes to the level of consciousness within our community.

As I typed this message, my hands were shaking, my heart racing. Never had I been so up-front, so out there about an issue that hit so close to home. It was nerve-racking. But after posting it, I felt overtaken by an instant sense of relief. I felt the burden of being a black Muslim woman suddenly lessen as I now placed the onus on the Muslim community to assist me in carrying this weight. I affirmed my own pain and experiences by speaking up and making it known that I do exist and that I will not be silenced.

As Muslims, we love to rally against all things Islamophobia—as we should—but in the same breath, we disregard other issues of racism and discrimination that pervade our community. It's not enough to say that you are not racist yet be silent in the face of racism's manifestation. Just as xenophobia and Islamophobia require inner work and reflection by their perpetrators, so does racism. Islam preaches diversity and inclusion, but we need to ask ourselves: Are we upholding that standard? How are we, in everyday practice, being intentional about making acceptance and antiracism the norm in all of our interactions, both within and outside of the Muslim community? How are we creating spaces for black Muslims to be authentic in their Blackness and Muslimness, and to feel comfortable in sharing their stories? These are the kinds of critical questions that we as Muslims need to answer if we wish to truly live as one *Ummah*. Not just in the feel-good, superficial sense of the phrase, but in a way that acknowledges and embraces each person's humanity.

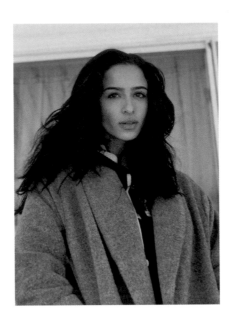

fatima *23, Akron, Ohio, USA*

Our colors became our pigments. Our pigments became our prisons. Being the victim of racism feels a lot like serving twenty-five to life based on someone else's decisions. W. E. B. Du Bois referred to this concept as "double consciousness," which describes the sense of always looking at one's self through the eyes of others, instead of allowing the self to have its own experiences. This is what experiencing racism feels like, day in and day out.

Many of those who experience racism on a regular basis become desensitized to its symptoms. I was bullied in high school when I wore the *hijab*. I have seen racism in line at the grocery store checkout. I have seen it be resentful of my bilingual tongue. I have seen it look over its shoulder at the airport, at the hospital, at the mall. I have seen racism smile to my face and tell me to have a nice day. Dealing with racism feels a lot like paying my dues for a crime I never committed. My melanin is apologizing for casualties it had no part in. And I'm certain even if I gave all my apologies to racism, I still wouldn't be forgiven.

I don't have one story about meaningless hate. It comes in so many different forms. But so does love. Love comes more quietly, and much more humbly. It comes in soft words and gentle actions. Hate may be louder, but love is far more abundant.

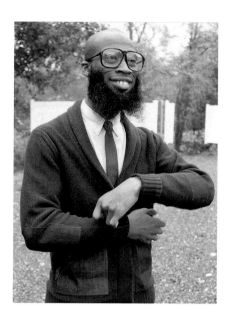

gareth *26, New York, New York, USA*

A while ago, I attended a summit sponsored by the Muslim World League in New York City. As I listened to the lectures and presentations, I realized there was something missing: representation of Muslims like me. Muslims who look, walk, talk, eat, dance, joke, and act just like me. Muslims of African American, Latino American, and European American descent. We were not represented at this conference, as though we weren't valued members of the "Muslim world." I stuck out like a sore thumb and felt a deep sense of isolation. It was disrespectful that at a "Muslim World" summit hosted by a Western nation, no Muslims native to this part of the world were represented.

For me, as a Muslim, being universally accepted amongst one's own international religious community is very important. The ideals of human unity within Islam, taught by both the Quran and the Prophet Muhammad's *(PUBH)* life and work, indicate explicitly that all Muslims have equal stake in the world. However, Muslims from specific segments of the Muslim world— especially those from the Middle-East, Muslim countries, and Muslim Major- ity countries—continue to proliferate a narrative that only Muslims from those regions are valid and deserving members of our community. I have often been excluded from Muslim spaces, or ignored because of my status as a Western

Muslim of color. My experiences as an African American Muslim man are proof of the stigma Muslims like me face. Regardless of my adherence to the tenets of Islam and the conviction of my religious beliefs, I sometimes fear that I'll never be accepted as a full-fledged member of the "Muslim World," simply because I am seen as a product of the Western world. This is a hurtful and frustrating perception with which I struggle on a daily basis.

How can cultural rapprochement be accomplished when Muslims from the United States and Latin America are not even considered members of the of the Muslim community? Why is it that the Muslim world is only classified as nations from Arabic-speaking countries or Southeast Asia? It's necessary for all Muslims to finally pay attention to these questions and attempt to answer them.

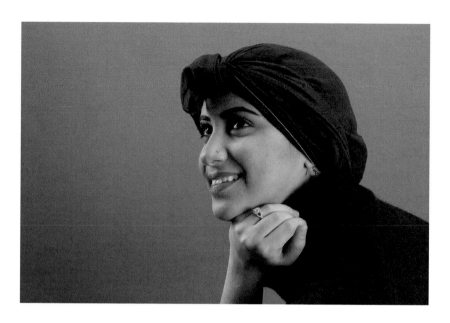

reem *23, Chicago, Illinois, USA*

I worked at Walgreens as a pharmacy technician, and one day after my shift, I stood outside talking on the phone while I was waiting for my ride. An old man honked at me for five seconds. I was nowhere near him, but he wanted me to move. If you close your eyes for a moment and think about it, five seconds is a really long time. Was this necessary? I didn't let it get to me—I just moved away, not paying any attention to him. But he got out of his car, walked up to me, and asked me very aggressively if I worked at the Walgreens. I chose to re-spond in a respectful way, despite his tone. I told him I did, and politely asked him if he needed any assistance finding something. Then he said, "They let you wear that crap on your head? This is America! Take that shit somewhere else or get out of here. You disgrace Walgreens!" Then he threw a cup of water at me.

By then, my brother had arrived at the scene and another man had started to defend me. I just stood there confused and in shock, wondering, "Is this guy serious? Did he just throw water at me because I'm wearing a scarf? A single extra piece of clothing?" I saw that the man was so old that he could barely walk by himself, and I realized that he must have had some serious issues to go out of his way to do what he did to me. But, by being a *hijabi*, I have a marker on my head that shows I belong to the Muslim faith. Therefore, I

chose to act in a sane manner to honor this beautiful religion of mine. I told the man his words didn't hurt me and that I'd pray for him. I told him I was proud of who I was, and there was nothing he could do or say to change that. I told him that he should be ashamed of his actions.

Afterward, a few people came up to me apologizing on his behalf. I took down his license plate number and tried to collect myself. I realized that the cup of water could have been a cup of hot coffee. He could have had a gun. So many things could have happened differently, but *Alhamdulillah*, it was just a cup of water.

This is America, a nation of immigrants. I have the right to wear whatever I want. That's freedom. That's America.

"

I told the
man his words
didn't hurt me
and that I'd pray
for him.

zaheer *54, Paradise Valley, Arizona, USA*

In 1970, my parents moved our family from Model Town, Pakistan—the only home we ever knew—to a strange and exotic new land: Carmel, Indiana. As a six-year-old Pakistani kid who didn't speak English, I was struck by the language difference, but there was an even bigger issue to face: American food. The smells and taste of the food in the College Wood Elementary School cafeteria nauseated me at first. What was this monstrosity called "Bacon Cheeseburger Pie"? I had so many questions: 1) What is bacon? 2) What is a cheeseburger? 3) Why should these disgusting items be combined? My mother did the best that she could and packed *desi* food in my red *Aladdin* lunch box. Eating this food in the school cafeteria only made my differences more obvious. I would always get at least one, "Ew, what is that?" from my classmates during lunch period. I wanted to tell them that my food was high cuisine compared to this "beef stroganoff" that everyone was shoveling in their faces, but I held back because I wanted to fit in. Of course, when I got home, my mother would always have delicious Pakistani food ready for our family. Growing up, that was pretty much my daily diet.

 In 1972, a family on the south side of Indianapolis hosted a Thanksgiving dinner and invited my family, as well as several other immigrant families,

"

I am thankful
for open-minded
friends like
Steve who helped
me traverse
the American
landscape, allowing
me to remain
proud of my culture
while still being
proud to be an
American.

"

to experience the holiday tradition. I saw the turkey and all of the fixings, and I remember thinking, "I think I like this stuff!" I treasured that day as a novelty, an unlikely dining experience. Afterward, my family and I returned to our routine of eating Pakistani *desi* food virtually 365 days a year.

On Thanksgiving Day 1973, something transformative happened. My mother did not make *desi* food. Instead, she prepared a turkey, mashed potatoes, cranberry sauce, stuffing, yams, and carrot cake. I was in shock and in heaven! I remember sitting at the table and thinking, "Today my family is eating the same stuff that all of my friends at school are eating. Today, I belong!" It was a strange relief. Every year after that, my family made a big deal out of Thanksgiving. On that day, we embrace the American culinary rituals. It was, and still is, my favorite holiday. Thanksgiving is *the* American holiday. It is non-denominational. It isn't commercialized. And more importantly, it celebrates family. Who doesn't have something to be thankful for?

Despite the glory of Thanksgiving, I was still trucking my red *Aladdin* lunch box full of *desi* food to school every day. I would eat with my head stuck in my lunch box, trying to minimize the sight and scent of my "strange" food. Eating *desi* food in the school cafeteria was a delicate operation: Eat fast and get rid of the evidence. If done correctly, friends would ask at some point during lunch, "Hey, did you even eat today?" "Yes, in fact I did. It was Bacon Cheeseburger Pie."

Then in the fifth grade, my friend Steve Pittman sat near me at lunch. I was eating an *aloo paratha* (potato-stuffed unleavened bread made on a skillet), doing my best to eat it quickly and covertly, but I struggled, because *aloo paratha* is absolutely delicious and I didn't want to rush it. Then my worst fear came true: Steve saw my *aloo*. I should have stuffed it down my gullet in fifteen seconds like I usually did, I thought. But Steve asked, "What's that?"

Reluctantly, in whispers, as if giving away state secrets, I gave him an explanation. "It's *aloo paratha*," I said. "A apooo frittata?" Steve asked. "No. An *aloo paratha*." The jig was up. I was sure Steve would grab my lunch pail, show it to everyone, and I would be banned from the cafeteria for life, relegated to eating my lunch outside by the tool shed with Petey, the one-eyed groundskeeper (whom I suspected smoked and drank from a strange bottle in a brown paper bag).

I prayed that this would be the end of it. But Steve had other ideas.
"Let me taste it," Steve said.

"Steve," I pleaded. "You don't really want to do that."

"I'm pretty sure I do," Steve said. "Give it up."

"Steve, please. Just please. You won't like it," I begged.

"Zaheer. Give. Me. A. Taste," he said.

I was paralyzed with fear. He reached over, grabbed a piece, and tasted it. Then he loudly proclaimed, "That's delicious!" My heart skipped a beat. I stood up a little straighter. Steve had accepted my food! It felt like Steve had accepted me. I took the *paratha* out of my lunch box every day after that and proudly shared my "strange" food with Steve.

These days on Thanksgiving I am thankful for so much—my parents, my family, and my life in Arizona. But I am also thankful to that anonymous family on the south side of Indianapolis whose generosity of spirit introduced me to the wonderful tradition of Thanksgiving. I am thankful for open-minded friends like Steve who helped me traverse the American landscape, allowing me to remain proud of my culture while still being proud to be an American. Steve's public sharing of the *paratha* with me in 1975 had a positive ripple effect. My American classmates who used to express disgust at my foreign food were suddenly accepting of what made me different. People like Steve are increasingly important today. A lack of understanding of foreign cultures may seem harmless, but often it transforms into resentment.

All it takes is one Steve to set off a domino effect of tolerance. This tolerance also goes both ways: Just as a family on the south side of Indianapolis opened their doors to immigrant families such as my own, my Pakistani family accepted and even integrated the American tradition of Thanksgiving into our lifestyle. This mutual acceptance helped facilitate open conversation and friendships between different cultural groups, and for that I am most thankful.

hijab

*I tell my story not because it is unique, but because
it is not.*

—Malala Yousafzai

The first question I get asked when I
meet people unfamiliar with the concept of
hijab is, "Why do you wear that thing on
your head?" It's a simple question, but it is
loaded with misconceptions and prejudices
proliferated by those who judge a woman
by the way she chooses to dress.

Every Muslim, man or woman, who wears the *hijab* and dresses modestly may answer this question differently. I know I wear *hijab* because the freedom that allows you to go uncovered is the same freedom that allows me to choose to cover.

Hijab may be defined in a variety of ways by Muslims living in different parts of the world, but put simply it refers to the principle of modesty that applies to both males and females. The most visible aspect of *hijab* is the head covering that many Muslim women wear. As a result, those who choose to cover their hair and dress modestly have become the most easily recognizable members of the Islamic faith and therefore are the targets of the most criticism. In this chapter, we have chosen to highlight the struggle and the beauty of what it means to wear *hijab* in the West. For many women living in a Muslim majority country, wearing *hijab* is likely the social norm. Although such an environment may pose its own set of obstacles—such as the stigma around Muslim women who choose not to wear *hijab*—these stories shed light on what it means to practice your religion in a place where your religious expressions are not necessarily welcome.

Yet, it is not the cloth that oppresses a woman, but rather the ignorant mind that judges her by what is on her head rather than what is in it. When political institutions seek to ban the *hijab*, I wonder if anyone realizes that the very people who claim to "liberate" Muslim women who have been "forced" to wear the *hijab* are the ones taking away women's freedom of choice.

Difference is good. Difference is inspiring. Difference is empowering. Difference is what makes each and every human being beautiful. Being human sometimes means fearing what you don't know or what you perceive as different. But *hijab* is not scary, nor is it a symbol of terrorism or religious extremism. *Hijab*, like any other way of dressing, is a form of expression. Whether it expresses a love for God, a dedication to one's faith, an extension of one's love for fashion, or a heart steeped in modesty, the *hijab* is beautiful, too.

The hard truth is that wearing the *hijab* is not easy. Regardless of faith, we all share insecurities, and Muslim women often step out into the world on a day when their confidence is low only to be judged by others for their appearance.

To any Muslim woman who has experienced this: Hold your head high. Remember your strength comes from within. Your bravery, ambition, determination, and perseverance stem from a much deeper place than your appearance. The following stories about *hijab* remind us that *hijab* isn't just about what you're wearing; it's about your way of life.

—*Iman Mahoui*

"

Yet, it is not the
cloth that
oppresses a woman,
but rather
the ignorant mind
that judges
her by what is on
her head
rather than what
is in it.

"

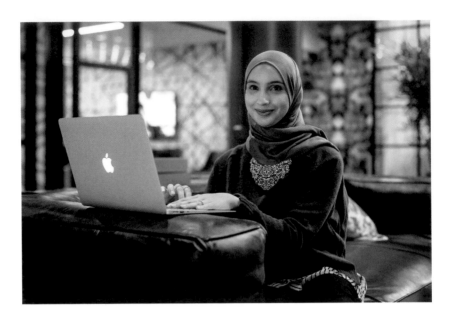

rowaida *26, New York, New York, USA*

To me, journalism is about finding my place in an industry that isn't so accept-
ing of me. It's about starting conversations that we are uncomfortable having.
Many journalists say they went into this field because they liked to write. I
went into journalism because I like to talk—just ask my parents. Growing up,
I was a curious child—I never stopped talking, whether it was about my day or
something I had learned. I would talk to anyone who would listen, and listen
to anyone who would talk. As I got older, I consumed all types of media, and
I became frustrated with the narrative surrounding Muslims and minorities. I
decided I had to do something about it.

 Being the only *hijabi* in a major newsroom is both a challenge and a
blessing. I realized the importance of my role when I had a heartbreaking inci-
dent on my way to work. I was was crossing a street in Manhattan one morn-
ing when a man screamed at me, asking if I was planning to blow anything up.
I was in a shock for a moment. I asked him, "What did you say?" but he only
nonsensically screamed some more as he walked away. I rushed to the sidewalk
to process what had just happened. I was born and raised in America and I
love it here! He took one look at me and my *hijab* and decided I was a terrorist,
when in fact I—probably like him—was simply on my way to work.

"

I want to deliver the
message that
more minorities and
Muslims are
needed as journalists,
especially at a
time when the very
Muslim identity
has been politicized.

"

"

Success and
hijab are not
contradictory;
they are
complementary.

There are so few Muslims in the field of journalism. The problem is glaring, and it puts a lot of pressure on Muslim journalists to serve as go-to guides to Islam, which can be an incredibly complicated position to be in. Your religion becomes your identifier. You might be a journalist who focuses on environmental issues, but your coworkers see you as a constant resource who can help inform their stories about Islam. Being Muslim will always find its way back to you. This isn't necessarily a bad thing, but once you realize how visible you are, it takes some adjustment.

Another challenge is the relationship Muslim journalists have with the Muslim community. Because *hijabi* women are considered representative of Islam, there is a burden of expectation that we must be perfect all the time. Although this idea comes from a place of valuing us, there is both a sense of relief and a sense of anxiety attached to this assumption. The Muslim community is relieved that there is a Muslim person in media, but it is anxious about the ubiquitous, unfair coverage of Muslims across all media platforms. I find myself constantly on the receiving end of my community's relief and anxiety. There is pressure from them, as if I could fix the years of negative press overnight. The weight of this responsibility—of changing the narrative of Muslims, particularly Muslim women in *hijab*—feels like it's quite literally in my hands. Going to work every day with that in the back of my mind can be exhausting.

But I'm grateful for my experience and I wouldn't change a thing. Wearing *hijab* in this field has only motivated me to excel in all that I do. My work focuses on Islamophobia and the Muslim community here in the United States. Each of my identities—young, Arab, Muslim, woman—has only widened my lens as a journalist. I want to deliver the message that more minorities and Muslims are needed as journalists, especially at a time when the very Muslim identity has been politicized. A lot of my work involves making sure we are producing nuanced and complex stories about Muslims that reflect the richness of our community, not simply ones that constantly tie us to national security and foreign policy. It's a lot for one person, but it's a goal that is close to my heart.

Don't ever think you cannot be successful because of your faith. This is the furthest thing from the truth and yet Western society repeats this lie to the Muslim community, and sometimes we even hear it from our own family and friends. There are Muslim women in Islamic history who were fearless leaders and whose faith only propelled them further into success. Success and *hijab* are not contradictory; they are complementary. Your *hijab* is your own.

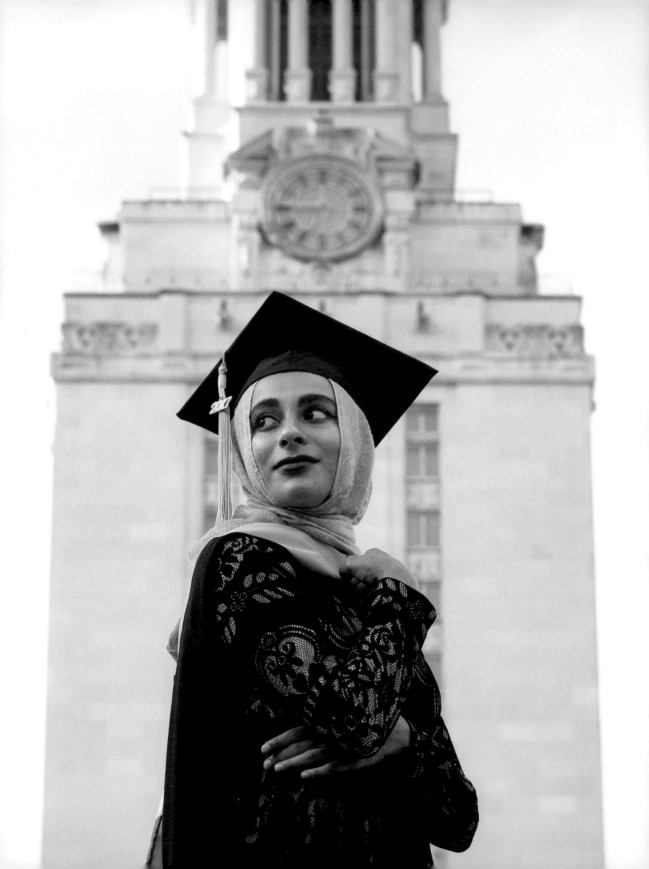

sara *23, Dallas, Texas, USA*

I have worn the *hijab* for ten years. With every year comes a new layer of understanding what *hijab* actually means. I can barely recognize myself in the girl I was before I made the choice to don the *hijab* permanently. However, one feeling has remained the same: *hijab* is extremely difficult, and every *hijabi* wrestles with it in her own way. I think about how ironic it is that while there are tyrants working to eradicate Islam completely, Muslims are bickering about how exactly one should wear the *hijab*—how terrible it is if one strand of hair shows, or what part of hell is reserved for a woman that doesn't wear the *hijab* at all. I also went to a *Khutbah* recently in which the speaker equated a Muslim woman taking off her *hijab* to someone earning interest off of money. My blood was boiling, and I left feeling exactly the opposite of how one is supposed to feel when departing the *masjid*.

 I am sick and tired of hearing white-passing male scholars attempt to make women feel less Muslim if they don't wear the *hijab* or if they choose to take it off. Let's be very clear about something: I love my *hijab*. I don't plan to take it off, God willing. It has taught me discipline and modesty. It has taught me to represent myself in the best manner possible. But at the same time, I do not think that *hijab* is one of our five pillars of Islam. Not wearing the physical *hijab* does not take one outside the fold of Islam. There are acts of worship that explicitly define us as Muslims—things like prayer, the belief in one God, fasting, charity, and good character, among others. But unlike something unambiguous in the Quran/*Sunnah*, such as establishing prayer and fasting in Ramadan, *hijab* is a gray area and its practice has evolved drastically throughout the centuries and in different regions. Wearing the *hijab* itself is not one of the acts of worship that defines one as Muslim or not.

 This is not to denounce the importance and symbolism of *hijab*. I just would like to put things in perspective and ask that we stop making *hijab* so black and white when it was never intended to be. The *hijab* is an issue that has been debated back and forth for centuries, and if it was as well-defined as praying or fasting, there would be no argument about it. It is appalling to see people publicly bash our Muslim women and how they choose to wear the *hijab*, or attempt to impose the *hijab* on them if they choose not to wear it.

 I have my own opinions about the *hijab*, and they have changed radically over the years, but wearing it is an act between myself and my Lord. I will

"

So if you
don't
wear a *hijab*,
stop telling
me how
and when to
wear mine.

"

practice what I believe while supporting other Muslim women who choose to practice *hijab* how they believe. When people are working to divide and destroy us, we must join hands with our Muslim sisters and stop judging each other by the way we wear our *hijab*s. We must stop judging those who choose not to wear the *hijab*. This piece of cloth has sadly evolved to become a primary marker of one's faith, which is superficial and counterproductive to what the *hijab* actually represents. *Hijab* has come to mean something different to everyone. So if you don't wear a *hijab*, stop telling me how and when to wear mine.

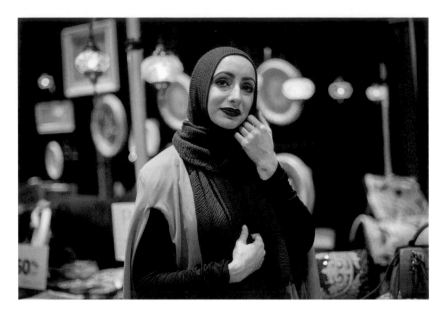

adwaa *28, Chicago, Illinois, USA*

I didn't completely understand *hijab*, and I didn't think it was right to commit to it unless I really understood what it meant. I respected women who wore it and were able to succeed in different areas of their lives, but I didn't feel it was right for me. It still seemed too restrictive for me, and I didn't think it was something I could practice.

I grew up what I like to call "culturally Muslim," meaning I was taught to follow Islam by watching how the people around me did it. Some aspects of Islam were strongly enforced in my home, such as not eating pork, not drinking, and not dating. But there were other parts of Islam that were not emphasized as much. I wasn't highly encouraged to pray or attend prayers at the *masjid*, or to listen to lectures or seek knowledge about the Prophets. *Hijab* was another one of those things. Some women in my family wore it, but many others didn't. Most of the women who did wear *hijab* did it because other women around them did—it was a culturally acceptable thing to do.

There were times when I assumed that *hijabi*s thought they were better than me, that they looked down on me because of how I lived my life and because I didn't dress as modestly as they did. I was wrong, of course. But I didn't know better at the time.

"

But I remind
myself that every
act of faith,
big or small, will
always be a
source of struggle.

"

About six months before I decided to wear *hijab*, our family was hit with a tragedy. I woke up one September morning and learned that my cousin, who was just thirty-one years old, was killed in a car accident. He had his whole life still ahead of him, but then he was gone. I thought, "That could be me." I spent the next few months doing a lot of soul searching. I wanted to figure out how to live my life better. I wanted to stop putting things off and do what makes me feel happy and fulfilled right now.

I went through a major spiritual rollercoaster during these months. It took a toll on me mentally, emotionally, and physically—at one point I was even in the hospital because of my symptoms. But through it all I had faith that the situation wasn't breaking me down. Instead, it was removing things from my mind and heart that weren't serving me, and eventually Allah (*SWT*) would help build me back up again.

At the start of the new year, my best friend told me maybe things would get better with a fresh start. I decided to read the book *Reclaim Your Heart* by Yasmin Mogahed, and I realized that I had been approaching life all wrong. I learned that maybe I wasn't receiving the things I prayed for from Allah because I had not been living for Him in the first place. I only turned to Allah when I wanted more than what I was already given.

I finally understood at my core how misguided that was. I decided this would be the year I focused on my spirituality and my relationship with Allah. After almost twenty-eight years of not being thankful for everything I had been blessed with, I owed Him. I wanted to focus on what I could do to show Allah that I deserved forgiveness, mercy, and blessings. That is when I thought of *hijab*. During prayer one afternoon, it came to me that if I wanted to show Allah that I have forsaken the superficial things in life, I should wear *hijab*.

It was the part of my religion that would be the hardest to observe. I was very attached to my hair, dressing how I wanted to, and going to the beach.

If I wanted Allah to see I was sincere, I had to give all of that up. A few weeks went by, and I was finally at peace with my decision and with myself. Whether I lived just one more day or many more years, I would show Allah how grateful I was for all of my blessings by doing the one thing that would be the hardest for me to do. It's still a struggle every day. My faith is not always consistent. It has highs and lows. Some days I feel like I'm not doing enough, and other days I wonder if putting on *hijab* was the right decision. But I remind myself that every act of faith, big or small, will always be a source of struggle.

I work with and interact with mostly non-Muslims, so I worried that I would find myself in difficult or scary situations because of my *hijab*, like other women have experienced. But on the first day I wore *hijab* to work, everyone was so excited about it. My boss at the time told me how proud of me she was, and that she had so much respect for my decision.

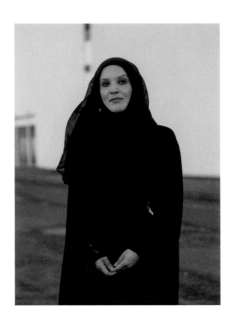

shabnam *38, Manchester, England*

I come from a Pashtun background in Afghanistan. As little girls, at the age of six, my friends and I would wear the *hijab* loosely on our heads as a sign of modesty. When I turned twenty I decided to wear it fully and completely cover my hair. I feel safer wearing the *hijab*. I think this is partially because I am doing what God has asked me to do, and I feel protected by His great power.

But *hijab* also causes others to judge. Some people find it extreme. In Manchester, where I live, it has never been an issue. Manchester is a diverse community, and it is very accepting of different cultures. Sometimes my white friends try on my *hijab*. We all understand that it is the person, not the *hijab*, that matters in any friendship. This is how it should be, but it's getting harder. Now it almost seems normal for Muslim women to be attacked once or twice in their lives for wearing the *hijab*. Fellow Muslims are paranoid about it. At my job, I used to work in the back where no one could see me. When we moved to an open space where the customers could see the employees, I was asked not to wear the black *hijab* because I was told I "look like a terrorist." And this comment came from my managers who are Muslim! Muslims are so terrified for our safety that we are hurting each other. This especially affects young Muslim women who don't feel accepted, even in their own communities. I wouldn't

stop someone on the street and tell them what to wear. Why do people think it's okay to tell Muslim women what to wear? Stand up for what you believe in. People will respect your beliefs once they see how respectful you are of them.

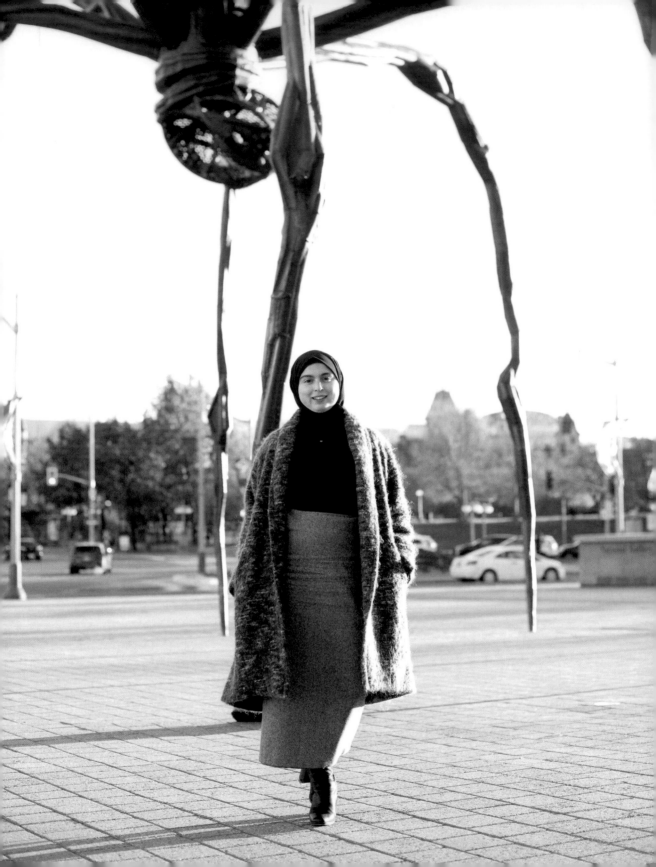

baraa *21, Ottawa, Ontario, Canada*

The headlines involving *hijab* seem endless. Last year, the modest swimwear often worn by Muslim women, known as the "burqini," was banned in the French Riviera. A few days after the ban went into effect a photo surfaced of a Muslim woman being forced to undress at the beach by French police officers. In my home country of Canada, a Muslim woman in *hijab* was racially targeted and attacked. The aggressor yelled: "I am a Nazi."

When I hear these stories, I sometimes wonder why I still wear *hijab.* Why do I endure the onslaught of hatred from strangers? Why do I suffer stares on public transportation from uncomfortable riders? Why do I risk my safety for the headscarf? My relationship with *hijab* has been extremely complicated, and not just for these reasons. Although its political symbolism in an ISIS-obsessed, post-9/11 world is undeniable, to me *hijab*'s complications lie in the personal dilemmas, hesitations, and insecurities it evokes.

When I first wore *hijab,* I did not associate any larger meaning with it. At the time, I did not understand the meaning of modesty, nor did I try to. To retro-actively impose those beliefs on myself as a ten-year-old would be unfair. I wore *hijab* simply because it would have been weird not to. This is how I explain it to my non-Muslim friends—imagine growing up around women like your mom and your aunts, with uncovered hair, and then as a preteen suddenly announcing you want to wear the *hijab.* It would be absurd. For me, the reverse was true: Wearing *hijab* was just a natural thing to do in my community.

Perhaps it was the naïveté of an eleven-year-old, but when I first wore *hijab* I did not feel different from my close friends of other faiths. My school friends shared my innocence. They would look at my *hijab* and ask questions out of sincere curiosity. "What is it like?" "Why do you have to wear it?" When they found out that I didn't celebrate Christmas they replied, "Oh, you're Jehovah's Witness. That's cool." That's the thing about eleven-year-olds: They don't associate meaning with a piece of fabric on some girl's head.

The insecurities around wearing *hijab* appeared in my life later on. I started to feel alienation and discomfort in middle school. *Hijab* meant I was "the weird girl." I did not dress like the other girls. I did not look normal, but most importantly I did not feel normal. At the same time, *hijab* did not protect me from the turmoil of being a teenage girl. *Hijab* did not make me immune to having crushes on boys, making dumb mistakes, hating my body, or having mental health issues.

As I moved through life, the challenges grew. Sometimes I blame my *hijab* for my being excluded in social situations, for not getting a job, or for not feeling beautiful. I feel I have to work twice as hard to get half of what those who blend in have. On the worst of days, I am deeply afraid my *hijab* means I will be assaulted as a recognizably Muslim woman.

All these insecurities mean I must continuously question and reaffirm why I wear a *hijab*:

I wear *hijab* because I want to.
I wear *hijab* as a feminist, as a woman, as a Canadian.
I wear *hijab* to hold myself morally accountable.
I wear *hijab* for God.

Although these are the beliefs behind my choice to wear *hijab*, daily insecurities taint my experience. I cannot help but imagine that life would be easier without a piece of fabric around my head. So yes, I think about taking the *hijab* off. Even though it is a personal choice, I often have to justify it to strangers.

To wear *hijab* is not a simple or an easy choice. It is not an isolated act. Mix in the politics of fear, the War on Terror, and exclusive feminism, and many days wearing the *hijab* seems almost impossible. Sometimes I ask myself, why do I bother carrying the burden of *hijab*'s political and religious symbolism (quite literally) on my head? My relationship to the *hijab* is not stagnant. The very act of perpetual self-inquiry makes *hijab* meaningful to me. My *hijab* has given me the opportunity to be a part of something bigger than myself. The insecurities and hesitations *hijab* prompts push me to acknowledge I am a work in progress. I am imperfect but determined to be the best version of myself and to stand firmly in what I believe.

"

I wear *hijab* because
I want to.

I wear *hijab* as a
feminist, as a woman,
as a Canadian.

I wear *hijab* to
hold myself morally
accountable.

I wear *hijab* for God.

"

"

. . .hijab is a
representation
of something
greater than any
one article of
clothing. It represents
modesty and humility,
which apply to all
the adherents of
Islam, whether they
are male or female.

"

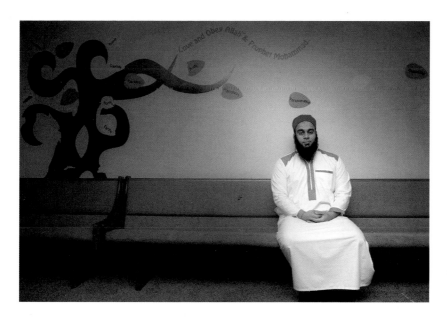

shamaas *27, St. Louis, Missouri, USA*

If one were to look up the meaning of *hijab*, one would find the following definition: "a head covering worn in public by some Muslim women." *Hijab* is literally defined as something that is exclusive to women. But I'm here to tell you that that is not the case.

If you look beyond this definition, you'll gain insight into *hijab*'s true significance. The word itself translates to "barrier" in classical Arabic. The idea of *hijab* is to be a barrier for a woman to shield her beauty from unwelcoming eyes. Why is it that only women have to shield their beauty from men? Why must a woman cover up while a man can do as he wishes?

But there is a *hijab* for men, too. It doesn't involve them covering their hair, but it does require them to cover themselves modestly like anyone else. Often our understanding of modesty has been limited to women, but our tradition teaches us modesty is for both men and women. This is apparent in the statement of the Prophet *(PBUH)* "Modesty is good in its entirety."

In Islam, a woman is told to cover her hair, while a man is told to cover his body. A man is not allowed to wear any clothes that are tight fitting, like muscle shirts and skinny jeans. A man's modest obligations are overlooked by Western society. It is thought that Islam gives complete freedom to a man.

In actuality, Islam is a religion of balance. A man is also encouraged to wear a *kufi*, similar to the Jewish yarmulke. A man wears it on his head to show modesty and humility to his Lord.

In Islam modesty comes in many forms: a *hijab*, a *kufi*, a *thaub* (a long white garment), and an *abaya* (a black garment worn by women). It is not bound to any one item of clothing. To say that only the *hijab* captures the true sense of modesty or that it only applies to women is incorrect, because the *hijab* is a representation of something greater than any one article of clothing. It represents modesty and humility, which apply to all the adherents of Islam, whether they are male or female. The next time someone says that *hijab* is something that objectifies women or creates a double standard because men don't have a *hijab*, we can tell them that a man must also wear *hijab*. It just takes a different form.

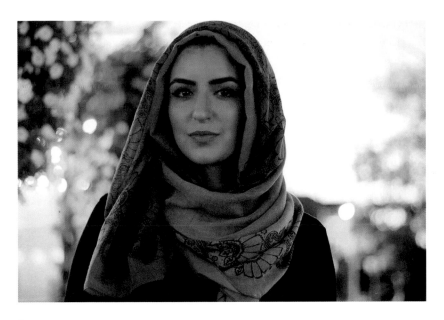

jana *24, Columbus, Ohio, USA*

I was twelve going on thirteen when I first wore the *hijab*, and there was little spirituality involved in making that decision. At the age of twelve I viewed religion like a video game, a series of hoops I needed to jump through in order to collect the most points. Collect enough points and get closer to fulfilling my obligations to God. Fulfill my obligations to God, and I would be spared His punishments. It was all very logical and methodical. But at the age of twelve, I was also weighing the inconvenience of *hijab* in my life. How would I alter my soccer uniform? Could I still spar during martial arts? And what on earth was I going to do with all my T-shirts? I was able to come to terms with those scenarios, and I have been wearing *hijab* for more than a decade now.

 Hijab is the most overt representation of Islam. For this reason, it is also one of the most hotly contested manifestations of the faith. There are differences of opinion as to whether it is obligatory or not, all stemming from real experiences that cannot be discounted. Every woman who chooses to wear the *hijab* has a unique, valid, and personal reason for doing so. I can honestly say that my relationship with *hijab* has changed since I began wearing it. It feels like it is no longer solely an obligation; it is a duty. I have realized that despite all the changes in my life—graduating college, landing my first

"

I have chosen
to take up as
much space
as I can.
I have filled
rooms
with my *hijab*.

"

job, getting into law school, and finally passing the bar—my *hijab* has been constant.

I have, more often than not, been the only *hijabi* in a classroom, in a workplace, and on a stage. And with that increased visibility, rightfully or wrongfully, I have been entrusted with a duty of representation. It is often unfair, exhausting, even frustrating—but for every interaction, I ask myself, would I rather someone else be entrusted with this duty? Would I rather have my faith and my *hijab* spoken about by those who have not lived the experience, or would I rather exchange some discomfort for some space and representation? I have chosen to take up as much space as I can. I have filled rooms with my *hijab*. And I have insisted on doing my part to reframe what a Muslim woman wearing *hijab* can do.

Hijab is this beautiful, complicated, multifaceted thing, and while I love it, I would still absolutely be who I am without it. And therein lies its beauty, because a garment does not fundamentally change an individual. An individual, however, can change the perception of a garment, and that is what a *hijabi* does every day.

ruma *28, Detroit, Michigan, USA*

Hijab is for me and my Lord. I didn't always know this. I learned it through tests, trials, and experiments. At a young age I was told I had to wear this scarf on my head, and if I didn't, it was shameful; that's all I knew. At the age of twelve, I began wearing it to school, where I would open up my locker, take it off, and leave it there. I didn't want to wear it. I liked my ponytails and curled hair. I didn't want to be different. This went on for a year or two. When I entered high school, I did the same thing. The school bell rang, and the *hijab* came off. As long as you wore *hijab* for show, it was all right. Four years later I started college, which had a major impact on who I was and who I would become. The beautiful people I met in class, at after school activities, and at religious events on campus changed my entire view on *hijab*.

I guess people are right when they say your surroundings are really important. I started attending Muslim Student Association (MSA) events. I decided I would wear the *hijab* "full-time" because I was a "part-time" *hijabi* for way too long. So instead of taking it off, I kept it on. Did I understand why? Not yet. I met a few girls through MSA and one of them did not wear the *hijab*. But when it came to her five daily prayers, she was right there in the corner of the library side by side with us, with her shawl in her purse, ready for each prayer. I respected this so much. It changed everything for me. Did I still struggle with *hijab*? Yes. Did I give it the respect it deserved? No. I played around, allowing myself to take it off here and there, walking down the street without it on. But with time, I became more comfortable wearing the *hijab*.

Fast-forward years later and *hijab* serves as a constant reminder to me to be humble and remain grounded. It allows me to feel respect for myself just as my respect for God was cultivated over time. My *hijab* is no longer for show, for the opposite gender, or for my family—it's for me. I can still listen to rap music, dress up, have opinions, and be educated with my *hijab* on. *Hijab* will never limit me. It has liberated me. My *hijab* is a reminder to me of the next world, and that's why I have it on.

hala *58, Huntington Beach, California, USA*

In 1979 my father made the decision to leave our home in Syria and move to the United States. The plan was that my father would come to California first, and then my mother and I along with all my siblings, would follow. Our travel itinerary included a layover in New York, then a connection in Chicago on American Airlines Flight 191 before finally arriving in California.

At the time, all immigrants had to first apply for a green card before traveling to their next destination. I had recently put on the *hijab* and loved it deeply. The immigration officers in New York asked me to remove my *hijab* for my green card photo, but I adamantly refused. They kept repeating that I would not be able to move or board my next flight until I took the photo. Eventually they even threatened to revoke my immigration status and send me back to Syria unless I removed my *hijab*. But I steadfastly refused, saying I would rather obey God and forget about my immigration. I loved the *hijab* that much.

By now my mother was impatient, having flown halfway across the globe and spending close to our entire life savings on these plane tickets. She didn't want us to miss our connecting flight out to California. She missed her husband, and was exhausted and terrified, so she pleaded with me to remove my *hijab*. But I continued to refuse. The officers called me into the back room and had my family members walk into the room to try to convince me to take my *hijab* off. I told them, "It does not matter who you call back here to speak to me, I will not take my *hijab* off my head for this photo."

The officers called their supervisors, and three long hours of interrogation later, they finally released me and allowed me to keep my *hijab* on for the photo. By then it was too late; we had missed our connecting flight. I felt terrible because we didn't have a lot of money left, and we were worried we'd have to purchase new plane tickets and stay overnight in New York. However, the airlines eventually gave us tickets on a later flight that was direct to California. Furious, my mother lectured me the entire trip.

When we finally arrived at LAX, my father greeted us all with the biggest hug. He was crying uncontrollably. He kept repeating to us, "Thank God you're alive! Thank God you're alive!" We were confused. Why wouldn't we

be alive? Finally he told us, "Flight number one ninety one, the original flight you were supposed to get on, crashed. All two hundred seventy-one people on board died instantly." We were all in shock. *Hijab* saved my family's life.

"

Hijab saved
my family's life.

female empowerment

My value as a woman is not measured by the size of my waist or the number of men who like me. My worth as a human being is measured on a higher scale: a scale of righteousness and piety. And my purpose in life—despite what fashion magazines say—is something more sublime than just looking good for men.

—Yasmin Mogahed

Our fight as women has never been about discovering the power within us, because let's be honest, we've always known it was there. It isn't about asserting female dominance either, as is a common misconception.

Empowerment is defined as establishing and reclaiming that our place in society comes with certain inalienable rights, including the rights to equal opportunity, pay, positions of authority, and safety. Women have always deserved those rights as human beings, but men have used religion and culture to force equity and equality through a patriarchal lens, shaping the reality of women for centuries. My identity as a "Muslim woman" has always defined my experiences (whether I like it or not), but the duality of such an identity often goes unacknowledged by many—both Muslims and people of other faiths. When I walk on to a panel of all men, my femaleness is further highlighted by the ever-present *hijab* on my head. Facing the world as both a Muslim and a woman has truly taught me the meaning of privilege.

But what is privilege? When I spoke with my own father about his privilege as a white man, I was surprised by his defensiveness. As an immigrant from Algeria who struggled to make it in America as a Muslim man, he was shocked that I would label him as a white man. But I explained to my father that privilege can be understood as the absence of a negative bias based on your identity. Your identity is composed of many components: religion, gender, race, and even culture. Although my father did experience negative encounters as a Muslim man, the biases that serve as barriers to women and people of color are obstacles that my father will never have to overcome. He will never have to try twice as hard to prove his competency as a person of color, or as a woman.

The Western narrative about Muslim women usually involves words like "oppression" and "misogyny," yet Islam was the first thing to empower me. My religion taught me that paradise lay at the feet of my mother, and that my worth as a woman did not come simply from bearing children. In the Quran it is written:

> *Never will I allow to be lost the work of any worker among you, whether male or female; you are of one another. (Surah Ali Imran 3:195)*

My mother, the first feminist in my life, reminded me every day that my worth did not stem from my appearance, but rather from my kindness, compassion, empathy, and intellect. As Muslim women, our dreams of becoming artists, writers, doctors, lawyers, businesswomen, or politicians are validated by our faith.

Muslim women are constantly told by non-Muslims that their choice to be modest is antifeminist, and that Islam only encourages women to become model housewives. Yet every Muslim is taught to seek knowledge, empowering

both men and women with the importance of education. Knowledge is the greatest tool against ignorance, and Islam has liberated women and girls in every walk of life through education. Muslim women have borne the brunt of Islamophobic rhetoric, one that perpetrates the notion of oppression in Islam. Perhaps this rhetoric would change if we listened to real Muslim women worldwide speak about their experiences with Islam.

—*Iman Mahoui*

shahad *23, Ottawa, Ontario, Canada*

On the evening of January 29, 2017, six men lost their lives in a terrorist attack at the Islamic Cultural Centre of Quebec City.

The mass shooter, Alexandre Bissonnette, expressed his hatred of Muslims and immigrants by murdering people who were peacefully praying with their children and loved ones. This violent event shocked Canada and sparked many serious conversations about Islamophobia and xenophobia. I was a political staffer for my local member of Parliament at the time, and I had accompanied her to a roundtable of faith leaders in the region, other members of Parliament, and the Minister of Environment and Climate Change. There were no Muslim women at the table.

As the roundtable shared thoughts on how to move forward, create interfaith and intercommunity dialogue, and change policies, I could not get over the fact that no Muslim women were asked to be part of this conversation. Muslim women are the most visible members of the Muslim community. When I walk into a room, I know that the first thing anyone sees is my *hijab*, and that everything else comes second. *Hijab* is also accompanied by stereotypes of vulnerability and weakness, which is why Muslim women are more often targeted by violent acts of Islamophobia. So why were those who face

" Muslim women
are the most visible
members of the
Muslim community.
When I walk
into a room, I know
that the first thing
anyone sees is my *hijab*,
and that everything
else comes second. "

Islamophobic violence at a disproportionately high rate not at the table, talking about their own experiences and suggesting ways to make change? Are we not the true experts on the subject?

I decided to break one of the unsaid rules of being a political staffer: I took the mic. I asked those present to be more mindful of the importance of representation, and how it influences the decisions we make and the policies we create. I shared my experience as a Muslim woman and how being so visible affects me every day.

A few months later I attended a lunch hosted by one of the most senior women in our government. She invited us to share our experiences as women in politics. She started the session with a relatable story: A young Muslim woman approached her after an event and raised the same concern that I had. "When our community is consulted, you speak to organization leaders and *Imams*," the young woman said. "But women are often in the driver's seat of our community, and spearhead many of its battles, so why do we not get a seat at the table?"

The host reflected on how that interaction affected the way she sees our government bettering its process of consultation, and how it had shown a need to be more intersectional in our fight for female voices.

It takes courage to bring your voice to an issue, especially when no one has made room for you. Maybe you've even been pushed out. It's a battle to get that seat and the mic, to project your experiences and thoughts, and get those in power to listen. But the battle is worthwhile. The battle starts when a young woman casually brings her concerns to the senior official. It starts with being vocal about the unacceptable composition of a roundtable or consultation room. Little by little our voices become louder, and gradually they are heard.

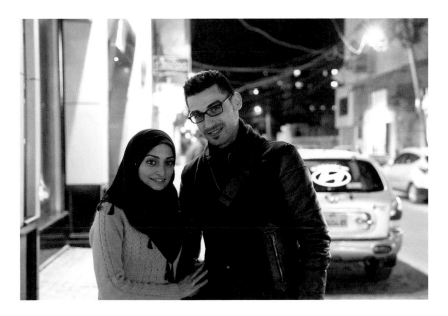

hadeel *27, Gaza, Palestine*

I was a prisoner in my own country. Gaza had been under siege for ten years. I had friends who had given up on their dreams of ever becoming someone in the world. Living in one place and not being able to travel for ten years suffocates you.

When I graduated from high school ten years ago, I told myself that I would work hard, travel, and study media at a prestigious college. But when I graduated, Gaza was still under siege and my dream vanished. Two years ago, I heard about a scholarship to study animation in Jordan. One scholarship would be given to a person from Gaza.

I wondered what kind of magic would make them pick me. I submitted an application, had several interviews, and a few weeks later, I received a full scholarship. I was thrilled! I was finally going to see the world! But first, I had to apply for a visa to go to Jordan.

As a Gazan, you need a visa to travel to the West Bank, then another from the West Bank to Amman, Jordan. I wasn't allowed to have both. I was denied six times. Each time my heart would shatter. Each time I would cry, seeing the only hope I had left fade away.

It costs money to apply for a new visa. My family spent everything we had trying to secure one for me. Where I'm from, women don't traditionally

Women need
to fight for their
rights. We
must resist social
taboos and
overcome political
obstacles or
our dreams will
fade away.

study the arts—let alone so far away from home—but my father was so supportive. He realized how important this was to me, and he was there every step of the way. A year passed, and I was still unable to travel. Some of my family members were actually happy, because they disagreed with the idea of women traveling alone. But my parents were there for me, and that's all that mattered.

During this process, I met Mahmoud. He was kind and smart, and he made me laugh like no one else. He wanted us to get married, but I told him about the dream I was pursuing, and how nothing would stop me from achieving it. In our culture, if you told a man you were leaving for three years, he would no longer want to be part of the relationship. But that day, Mahmoud held my hand and told me he was extremely proud of me. He said that I should do what I needed to do and that he would be waiting for me. I had been blessed with men in my life who empowered me, believed in me, and were as determined to help me achieve my goals as I was to achieve them myself. We got engaged and started preparing for a new life together. Then I got a phone call: "Your visa is ready; you have to leave at 6:00 A.M. tomorrow."

I was running around packing, hugging my mom, calling friends, calling Mahmoud, visiting with neighbors in our house—the house was a mess!

Everyone was saying their farewells as my three-year journey was finally about to begin. Once I got to Jordan I knew I wouldn't be able to go back for three years. My mind was in Amman, but my heart was still in Gaza. Women need to fight for their rights. We must resist social taboos and overcome political obstacles or our dreams will fade away.

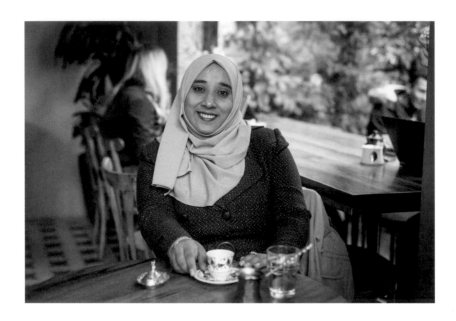

eman *38, Amman, Jordan*

No one tells us that our lives might not turn out to be what's considered "normal." As a woman, I was expected to be married and have a child by twenty-five. How would I be treated by society if this didn't happen?

I'm the youngest in the family, so I was spoiled. I was also part of a judgmental community. My brothers and sisters all got married as expected, but by the time it was my turn, my parents were too old to live by themselves. My mother was very sick, and she couldn't move around on her own. If I got married and moved away, who would take care of them?

My mom always imagined what my children would be like, but she never got the chance to see them. Or let's say, I never got the chance to have them. When I turned thirty I made the final decision that I would not marry. My brothers and sisters were busy with their own families, and some of them were living overseas. It was just me and my parents now. I would cook, clean, shop for them, tell them stories, take them on picnics and walks. It was exhausting, but they were worth it. My mom was a strong woman, and she went through a lot. It was very hard to see her so weak. Even though I gave up on marriage, I did not give up on being a productive member of society. I'd always wanted to be a journalist, but when I was growing up, being a female

journalist was like committing a cultural crime, so I'd given up that dream as well.

My parents became very sick. My mom couldn't eat anymore. We took her to a doctor and she was diagnosed with cancer. My mom was illiterate and couldn't read the doctor's report we had been given at the hospital, so we decided to shield her from the pain by telling her nothing was wrong. We just took her home. It was a strange night. People were in the house, but she left everyone in the living room and started walking around the house alone. It was as if she was already saying good-bye.

The next day we took her for another check-up at the hospital. As I was putting her into bed, she fell to the ground. I quickly threw myself under her so she wouldn't get hurt. She passed away, just like that. I think it's a blessing. My mom and I were so close, and I was the one to hold her in her final moment. I think it takes many years to actually realize your own mother is gone, for good. My dad got sick a few years later and passed away. I was left alone in a big house with no life. I had a degree in something that I love, but I had no parents to spend time with and my sisters and brothers were so busy.

Now I just turned thirty-eight, and I can happily tell you that I became a journalist. I fought to finally make my dream a reality. As the years went on after my parents passed away, I lost the meaning in my life. In such a patriarchal society, my decision to pursue journalism as a woman, and especially an older, unwed woman, was not an easy one. But, so many years later into my life, I no longer had anything left to lose. No one prepared me for what would happen if I didn't marry and was left all alone. If I hadn't gone to school, it would have been like a slow death.

Do I regret anything? I don't regret being single, as my parents were very precious to me. But I do regret not following my dream to work as a journalist earlier. I missed out on so much in this life, and a person only grows older.

"

We heal, we
learn, and then
we aspire to create
changes for our
sisters that
will start a ripple
effect around
the entire world.

"

rana *24, Palo Alto, California, USA*

I was ten years old the first time I saw a man lift his hand and slap his wife across the face in a public space. As I watched her eyebrows scrunch together in pain, a dark silence enveloped the street as bystanders continued on with their own lives. No one said a thing. That same year, boys at school started making sexualized comments about the shape of my body, and I learned about sexual control through hearing murmurs about female genital mutilation practices within my own community. When I was fourteen, my best friend told me that she had been sexually abused when she was seven.

I was just a girl when I began to volunteer at a domestic violence organization, and I eventually founded my own nonprofit that trains Muslim women in self-defense. Over the past seven years, I have built a movement with dozens of other girls, from both my community and around the world. I spent several months in Jordan's largest refugee camp with girls who escaped the Syrian civil war. I helped them heal from abuse and sexual violence so that they could feel strong again and raise their siblings and children. In Madrid, Muslim girls bore the brunt of discrimination and racism in classrooms and walking around their own neighborhoods. Their families had immigrated to make their lives better, and now this is what they had to face. In Tunisia, the

girls I met during self-defense instruction made jokes about what they would do to men who tried to attack them. These same girls then participated in a revolution that overthrew a tyrannical regime. And just recently, we all witnessed how powerful a girl can be as Malala Yousafzai enrolled in her first year at Oxford University. She was only fifteen when she stood up against the Taliban by demanding to continue her education.

When I listen to the stories of the girls I work with, I sometimes feel a prevailing sense of hopelessness. There is so much work to be done! But then I see their resiliency—how they overcome challenges with grace. We heal, we learn, and then we aspire to create changes for our sisters that will start a ripple effect around the entire world. This is the hope I have for our future. This is the power of a girl.

hadeel *27, Amman, Jordan*

We were on a family trip when we had a car accident. The whole family was in the car. I remember flying through the window and landing on my back on top of a rock. I was eleven years old.

After the accident, I was still able to use my legs. But after several surgeries, I got worse—I couldn't walk at all. My parents would always tell me, "You'll get better, we promise," and because I was just a little girl, I kept my hopes up. I think this was the worst part: that I had hoped I would walk again, because I was never able to. My parents only stopped telling me that after I told them how painful it was to live with that hope.

My dad would often cry because he felt so guilty about the accident. I wanted to change the pain my family felt when they looked at me. I started doing better in school, but I remember my principal was a nightmare. She would tell me that I was different, and I had no future. She underestimated me, but I didn't let her break me. I proved myself, and was a leader. I scored high grades and did well in all my activities.

I wanted to change schools when it was time to go to high school, but no one would accept me. No school was ready to accommodate my disabilities. Eventually my father found a school that would take me, and he installed

ramps around the campus himself. Later, college provided new challenges. There were no ramps, and the elevator was broken half the time, causing me to miss classes. What was even worse was that there was no bathroom for people with disabilities. Some of my friends who also had disabilities would have to go home early to use the bathroom, and some wouldn't eat or drink all day so that they wouldn't need to use the bathroom. We didn't even have the simple, basic right to use the bathroom.

We decided it was time for real change. We organized a protest and made our demands heard. We wanted bathrooms and the elevators fixed. My goal in life shifted to helping others like me. I started going to other schools and talking about people with disabilities and how we are labeled. I talk about how I managed to learn to drive and stand up for my rights. My parents are so proud of their fearless daughter.

shams *34, Jerusalem, Palestine*

I am an art therapist. In college, I received my degree in mathematics and computer science, but after being a math teacher for many years I realized I actually wanted to do something completely different. As a full-time mother I did what everyone told me I shouldn't do: I took night classes to get my certificate in counseling, with a focus on teaching groups about sexual education (a highly stigmatized field in the Middle East), as well as a degree in sustainable development in international aid.

This wasn't easy. I am an Arab woman from a conservative society where boundaries are already drawn for women, and there is an expectation of what we *should* be doing with our lives, as opposed to what we *want* to do with our lives. Every effort to break through those boundaries brought me opposition.

One day I received an email from a humanitarian organization based in Israel that was in need of volunteers in the field of psychosocial support for their branch in Greece. I was certain that social work was my calling. The only problem was that my identity as a Palestinian with Israeli citizenship made me hesitate. On the one hand, I wanted to use my education to help refugees; on the other, I didn't want to represent any political side that I wasn't associated with and that didn't match my own identity. After some deep thinking I decided to go against the opposition and take this opportunity. I soon became determined. The second challenge was to convince my husband. He thought news about the refugee situation had made a fleeting impact on me, and that my eagerness to help would end when the papers stopped talking about it. But he very quickly understood my conviction, and I packed my bags and began my journey.

I believed I was going to help the refugees with their mental and emotional well-being, and help them overcome the emotional trauma caused by war. I would guide them to search within themselves and find their true selves despite everything they had been through. I didn't know that my life was going to be the one that changed. Thinking about all of the things I was hoping to give to them, it never occurred to me that they would give me more in return.

Yet there was a moment when I doubted my choice. I had been in Greece about twenty days, and I was finally able to have a video call in with my children. My daughter Leen happily shared with me that she had finished her swimming class and could now swim like an adult. My daughter Dima was

excited to show me her new painting. But when it was time for my youngest son, Nour, to speak to me, he did not recognize me, and he asked his sisters, "Who is this strange woman on the phone?" His words hit me like a thunderbolt. I sat there crying in my apartment in Greece, hurt by my conscience telling me that I was a bad mother.

My team, who were with me for dinner and always there to support me, reminded me of what I had been telling the mothers in the refugee camps for weeks: "We are good enough mothers simply by the efforts that we make in order to be the best version of ourselves." So after I finished my first month of volunteering, I asked my children to join me in Greece. They were so happy that we wouldn't be apart, and so pleased that they would be part of such sacred work.

Whenever anyone asks me why I changed my profession from mathematics to humanitarian work, I always answer that every person should search within themselves until they find the true meaning of their existence. When teaching math no longer made me happy, I knew in my heart that it was my duty to discover what I was meant to do, no matter my age or circumstance. Everyone deserves to find what gives them purpose. To all mothers who doubt themselves or their choices: You have given life, and as such you must always remember that you are not merely half of society. Never underestimate your abilities.

"

Having a
voice is something
I can't take
for granted when so
many women in
this world are denied
the right to speak
for themselves.

"

tasneem *26, Denver, Colorado, USA*
(@TazzyPhe)

I recently received a message on my Instagram account asking me if I worry that I'll never get married because I've put myself on the internet. Frankly, I'm not worried. It's very possible that my online presence has scared away potential suitors. My parents are also concerned about this possibility, and it's one of the many reasons I worry that being a YouTuber is letting them down.

There have been many times that I wished God had wired me differently. I've wished that instead of having a passion for creative storytelling I had a passion for something more practical—like software engineering or medicine. Then maybe I'd be more at peace. I've wondered whether I'd be less stressed about my unconventional pursuits if I hadn't uploaded those first videos years ago. I've debated whether what I've dealt with—the negative comments, the unhealthy obsession over view counts on my channel—has been worth it. So far, I believe it has. I've been able to travel to places that have been on my wish list and connect with amazing people all over the world because of my videos.

I make videos about being a Muslim woman in the post-9/11 era. My videos range from short documentaries to comedic sketches. I find that my presence on the platform and the subjects I discuss make me controversial

in comparison to other YouTubers who do product reviews and tutorials. Sometimes I feel alone navigating the male-dominated areas of social media. Most of the well-known Muslim women on YouTube have beauty, fashion, or lifestyle channels. I know a fellow YouTuber who changed her content after receiving hateful comments. She switched from hilarious skits that allowed her to release her inner emotions and charisma to makeup tutorials because she thought it was easier and people would give her less heat for it. I understand why she did what she did. I think that we forget that it's not normal to be criticized as frequently as you are when you're on a public stage. It's not good for one's self-esteem. At the end of the day, we are still human.

Despite the challenges that I've faced on this journey, I feel blessed for the opportunities that making videos has given me. It is such a privilege to have a platform that allows me to be in control of my own narrative. Muslim women have been painted with the same brush for decades, and for a very long time, media was an industry solely accessible to an elite group of people. The internet has changed that. I love being able to share my perspective and stories without having to jump through the hoops of traditional media. Having a voice is something I can't take for granted when so many women in this world are denied the right to speak for themselves. It's something I've found quite empowering and that I am grateful for.

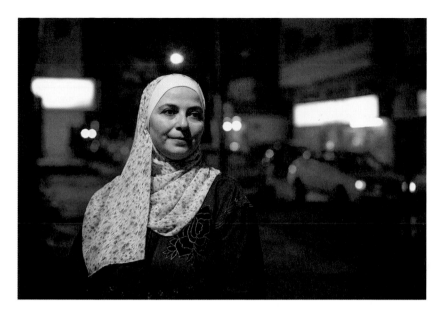

atika *47, Amman, Jordan*

My husband and I had what we called a "traditional marriage"; we met each other
through our families. I stopped going to college to travel with him while he worked.
We had a great partnership and four beautiful children. Eleven years into our rela-
tionship, he was diagnosed with a fatal disease and he died.

Suddenly I was a single mother who had no diploma and four
children. I would cry when I was alone at night, yet every morning I would act
like everything was okay as I got my kids ready for school. I realized I wanted
to stop asking my parents and my husband's parents for help and learn to
depend on myself. I made a huge decision: I decided to go back to school. I was
thirty-three years old and most of the other students were between eighteen
and twenty-three years old. I felt unwelcome in the classroom. It was hard
work. I would cook at 4 A.M., prepare lunch for the kids, send them to school,
and then drive myself to college. Then I would rush to pick them up, have
dinner, clean the house, help them with their homework, and then wake up
and do it over again the next day.

The hardest part was how I was judged. Some people thought I was
selfish for going back to school, and my love and dedication to my children was
questioned. I was accused of wanting to leave my children behind to start a

" Single moms
are not fragile—we
can be both financially
independent and
succeed in our roles
as mothers. "

new life. But I was determined to build a better life for myself and my children. I was a single mom, and no one else would be there for them the way I was.

Three years later I graduated with honors. People were shocked at what I accomplished. Magazines even wrote about me. At that moment, I knew how powerful a mother's heart could be. A mother will work harder and sleep less if it is for the sake of her children. A mother will work tirelessly to provide the best possible quality of life that she can. Single moms are not fragile—we can be both financially independent and succeed in our roles as mothers. My children also graduated with honors.

Looking back, I think the best part of the experience was when we were all at home at night. We were working together with tea and chips, all studying. We were all friends then, me and my kids. We were all determined to do the best for our family.

asma *32, Amman, Jordan*

When I was eighteen years old, I was excited to go off to college. I couldn't wait to be a student, but my parents did not want me to go. When a wealthy, good-looking man proposed to me, I said no. But my parents insisted I meet with him again. He was well mannered, came from a great family, and had a good job. What else could a girl ask for? I got married. My wedding was awful. My name wasn't even on the wedding invitations because my fiancé felt it was not culturally appropriate. I remember sitting at the wedding thinking, "If I run now, what will happen?"

My parents were strict, so at first I thought my life might be better as a married woman. I'd be free! But the opposite was true. My husband was verbally abusive. He would curse at me when the tea wasn't ready fast enough or if I asked him to take me to the mall. He never let me leave home without him. I wasn't allowed to see my friends. I was only allowed to go out with him once a month. I was stuck at home where TV and the internet were forbidden. He took my phone away, and he didn't even like me to read. I spent my time cleaning, cooking, and trying to look good. The abuse got worse—I once asked if I could visit my mom and he went mad, cursing my parents and breaking everything. I never asked again. I tried telling my parents that my husband was insane, but their answer was always, "He just has a bad temper. You will both work it out."

I got pregnant and gave birth to a beautiful baby girl. On her first birthday, I dressed her up in a special outfit. My husband didn't like it. He slapped me in the face and I fell on the ground. I was in shock! He had become a physically violent man. Weeks later he slapped me again and beat me because I visited my neighbor without telling him. I was pregnant with my second baby. It was raining outside, but I didn't care. I called my dad and ran out of the house and waited for him to pick me up. I was alone, pregnant, bruised, and bleeding, cold, and scared.

My parents made my husband promise to never beat me again. So I went back to our dark home. But things got worse. He had given me a phone as a gift, but when I asked if my mom could visit, he broke the phone so I could never call her again. I could only call her using his phone, while he was in the same room. I felt like I was going crazy. I had no one to talk to, no place to go, and I was attacked for having any opinions. My parents didn't believe how horrible he was, while my two kids saw all of this happening.

"

To any women out
there going
through what I went
through: It's hard,
but I am free now. The
freedom is worth it.

"

My parents were having a big family gathering, and I really wanted to go. I hadn't seen them for ages. I asked politely if I could go. In response, my husband walked into the bedroom, destroyed everything, and then went to work. When he came home, he saw everything he had broken was still on the ground. I hadn't cleaned it up. To be honest, it felt good—like the revolutionary Asma coming to life. But his eyes became red like the devil, and he started yelling, "Why didn't you clean that yet?" and hit me hard. The next day I thought, "Asma, you are twenty-five years old. You are beautiful, smart, and ambitious. Your life is being wasted with this man. Run!" I packed and left. Just like that. It had been seven years since the last time I rode in a taxi. I felt free, just being in a taxi.

I finally got divorced. No one other than our parents really knew why. I didn't want to share my story. I was slammed by society; people referred to me as "the woman who left her husband because she wanted to go to the mall every day," or "the woman who wanted to travel all the time," or "the woman who cared about herself more than her kids." This was very hard.

That was six years ago. Now I am a teacher and I'm working toward my master's degree. My ex-husband pays child support and I live in a small apartment with my kids. They only recently learned that their dad used to beat me. I had to tell them—I had overheard their friends saying I left their father because I was demanding. I can't risk losing them, and they needed to know the truth. I'm a single mom raising two strong children. To any women out there going through what I went through: It's hard, but I am free now. The freedom is worth it.

prayer

And seek help through patience and prayer.
But it is difficult, except for the devout.
(Surah Baqarah 2:45)

I grew up in a household where we were
taught to pray five times a day from a
young age. We were encouraged, through
example and reminder, to consistently
pray on time almost every day.

Prayer, most commonly referred to as *Salat* in Islam, is quite a unique form of worship toward God, to whom we owe our daily lives and spiritual success. Prayer is one of the five pillars of Islam, along with *hajj* or pilgrimage, fasting during Ramadan, giving charity, and belief in the oneness of God. Prayer is the foundation that each Muslim's faith is built upon, yet its importance is vastly undervalued. Because it can be difficult to pray on time five times a day, many regard *Salat* as an important but not vital part of their faith.

As I and my siblings grew older and our parents gave us more responsibility and freedom, praying started to play a secondary role in my life. I didn't stop praying altogether, but I would watch the sunset and marvel at its beauty, forgetting to give thanks to the One who created it. Prayer became a hassle, an unnecessary chore that complicated going to class and grabbing food with friends and interrupted movie nights. I justified my actions by convincing myself that my spirituality and closeness with God was not necessarily determined solely by my prayer habits. I told myself that going through the motions of prayer could not possibly bring me closer to God.

I didn't realize the gravity of my illusion until my anxiety worsened as I grew older, and a feeling of incompleteness pervaded my life. I decided to see if returning to daily prayer, along with meditation and exercise, might help. That is when I discovered there was a gap in my heart without prayer. It was small but had slowly grown bigger, and I didn't realize it was there until I filled it. We go through motions of prayer for the same reason that we carry photos of our loved ones: so that we may not forget. This brings us peace.

Little things, seemingly insignificant actions and objects, took on meaning. My anxiety lessened and days that were structured around prayer were never wasted. My academic and personal life improved. Self-reflection in meditation and contemplation and remembrance during prayer serve to soften the heart. To state that *Salat* gave my life and my world meaning is not an exaggeration.

This constant ritual provides stability. Prayer combines the inner workings of one's soul and mind with the physicality of bodily actions. When performed in congregation, it also provides a strong sense of community and serves as a reminder of the equality of people, uniting them through an action that creates a sense of oneness. Through such an experience one can understand the collective spirit. That is the beauty of *Salat*. That is the beauty of being Muslim.

—*Sajjad Shah and Iman Mahoui*

"

We go through
motions of prayer,
for the same
reason that we carry
photos of our
loved ones: so that
we may not forget.

"

"

Sometimes
belief
is all you
need
to feel safe
and
protected.

"

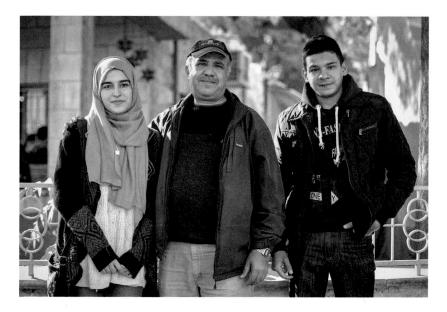

khaled *58, Amman, Jordan*

Twenty years ago, we didn't have cell phones and the internet the way we do today. Where I lived there would be just one or two landlines in each neighborhood, and people would have to pay per minute to use them. One day, I was at my job working as a guard when suddenly I started worrying about my daughter, Wasan. I felt something was wrong. I read some Quran verses to keep the bad thoughts away, but they kept coming back.

Every time I closed my eyes, I would see my daughter standing on the edge of a window, about to fall from the third story. It felt so real. I wanted to call my wife and ask her to check on Wasan, but the nearest phone was 30 minutes away. I thought about getting on a bus and heading home, but we lived an hour away. I felt stuck. I don't know if it was father's intuition, but I believed something bad was going to happen. I closed my eyes and started praying hard that my wife and Wasan would be safe. A few minutes later I felt relieved, but I didn't know why.

Later when my wife and I were talking at dinner, she told me about a scary incident that had happened that day: "Wasan was about to fall out of the window." I told her about the feeling I had earlier. It's hard to explain how I knew Wasan was going to have an accident, but I trusted that God would give

me the right tool to save my daughter. It wasn't the phone or transportation; it was the magic of prayer. I believed in myself, and I believed God was capable of saving my daughter. Sometimes belief is all you need to feel safe and protected.

anjum *71, Chicago, Illinois, USA*

My husband and I got married and decided to immigrate to the United States from India. My husband wanted to make sure our children would have the best lives possible. He was a great and dedicated family man.

When we arrived, the language was a barrier. I had a master's degree but couldn't find any work because I didn't speak English. My husband learned English faster than I did, and his business began to flourish. We had a great life with our beautiful son and daughter. I was a stay-at-home mom raising my two treasures.

It was challenging raising two children in a country that offers bright futures for children but has different values than the ones we wanted them to have. My daughter was obsessed with Western culture—the music, the clothing, the movies, the parties . . . When my son, Faisal, was on a break from school, he wanted to go skiing. The trip was too expensive for us, so I asked my husband to say no, but he said, "We work so our kids can live." My husband never wanted our children to feel inferior to their peers, and so we did our best to make them happy in this new country that we had told them to call home.

One night, not too long after Faisal's request, I was getting the table ready for dinner, and the news reported that there had been a fatal car accident, but that they could not identify the victim. At first, I didn't think about

177

"

When my husband
used to ask,
'Why do you still
pray?' I didn't have
a clear answer.
Now I would
simply say, 'We pray
so we can live.'

"

who might have been in the accident, but after a couple of hours, I felt a chill in my body, I knew something was wrong. A few minutes later, my husband called and told me he was heading to the hospital. It seemed that Faisal was in a car accident, and had been hit by a drunk driver. I got my holy book, prayer rug, and cap and rushed to the hospital. I promised myself I wouldn't leave unless Faisal was leaving with me, healthy. When I saw my husband, I knew my child was gone.

Our lives were shattered. We had moved to America and worked hard for our children, but we couldn't keep them safe. My husband started losing faith, and he stopped praying and fasting. When he saw me crying and holding the holy book, he would say, "This God took our son away from us."

My husband was a caring and gentle man. Suddenly he became a broken man, desperate to have his son back. A few years after the accident, my husband passed away. His broken heart could not survive the loss.

I was alone with a daughter who deserved a great future. I was left with 150,000 dollars' worth of debt and a mortgage. I started looking for any job that an old lady could do. I worked fifteen hours a day. Every penny I earned went to the bank. All of my earnings would cover the debt, and, after eight years, I finally paid it off. I lost my son and then my husband, but what kept me sane was God. Prayer gave me the power to wake up every morning and work harder. When my husband used to ask, "Why do you still pray?" I didn't have a clear answer. Now I would simply say, "We pray so we can live."

yaseen *11, Indianapolis, Indiana, USA*

I love Ramadan! It's the only time of the year when I can hang out with my friends all night and my parents won't get mad. During Ramadan, after we get done fasting for the day, many people come to the *masjid* for night prayer. While the adults are praying, a lot of us kids will go to the parking lot and play soccer or basketball. It's so fun to spend time with my Muslim friends, because it allows me to build a bond with them that will hopefully last forever.

People love Ramadan for many reasons—some people love it because the entire community comes together to pray collectively, some because of the delicious feasts we share after we are done fasting, some because we can play all night with friends and form bonds that will last beyond the month . . . No matter the reason, for me, Ramadan is the best time of the year. It is also one of the most spiritual months of the year, because we spend it rebuilding our connection with God. It's like our version of Christmas, and the best part is that we get to continue celebrating even after Ramadan has ended, with the festival of *Eid*!

"

It's so fun to
spend time with
my Muslim friends,
because it allows
me to build
a bond with them
that will hopefully
last forever.

"

abass *25, Vancouver, British Columbia, Canada*

"Supplication is the essence of worship." This statement from the Prophet, peace be upon him, can only be understood through experience. The type of experience that teaches us, humbles us to our knees, and reminds us that God has power over all things.

One of my favorite verses of the Quran speaks to this power. In verse 62 of the chapter "The Ant (27)": "Lo! He who responds to the one in distress when he calls Him, He removes the woe and makes you vicegerents of the earth. Is there another deity with Allah? How little do you remember."

During my junior year, I underwent some of the biggest transformations in my life. I was scouted by a top soccer trainer who saw great potential in me. He believed in me more than I ever could have believed in myself at the time. He took me under his wing and trained me multiple times a day. He let me join his club team and we practiced all the time. He taught me discipline, sacrifice, commitment, and dedication, as well as the importance of having a good work ethic and setting goals. I took the passion I've had for soccer since I was a boy to another level. I dreamed of playing soccer at the collegiate level.

The second transformation was with regards to my relationship with God. During my sophomore year I had been hanging out with the wrong crowd. I was confused and searching for meaning by trying different things. Eventually I started thinking about deeper questions: Why am I here? What happens after death? What is life really about? I grew up in an Islamic household, and I was blessed with wonderful parents who prayed and also encouraged me to do the same. But that wasn't enough. I needed to find answers to the questions that were stirring inside of me on my own. This led me to look deeper into Islam. I felt peace and tranquility whenever I found something that my soul recognized as truth. During my junior year, I grew physically and mentally through my dedication to soccer, but I also grew spiritually and intellectually in pursuit of truth and meaning.

These two roads clashed the summer before my senior year, when I experienced the distress spoken about in "The Ant." Around this time, most people have a list of the top five colleges they plan to apply to in the fall. But I truly had no idea what I was supposed to do with my life, or where I should go after high school. Would I pursue my dream of playing college soccer? Or would I follow this new passion of seeking truth and God through my deeper

" "

I felt peace and
tranquility
whenever I found
something that
my soul recognized
as truth.

study of Islam and spirituality? I remember playing soccer one week, scoring a goal and feeling joy from being certain I would stick with soccer. The following week I would attend an Islamic lecture and find such deep contentment being enlightened that I felt sure that this was my true calling. I couldn't make up my mind. People advised me to just take up both, but I knew myself and that I would have to fully dedicate myself to one or the other.

That summer, when the last ten nights of Ramadan came around, I put soccer on hold and went to spend those last blessed nights in the mosque. I had heard in some of the Islamic lectures a *hadith* that stated: "Our Lord descends to the lowest heaven on the last third of every night, and He says: 'Who is calling upon me that I may answer him? Who is asking from me that I may give him? Who is seeking my forgiveness that I may forgive him?'"

I knew that Allah (*SWT*) is closest to us when we are in *Sujood* and that it is one of the best times to make prayer. So I combined these two teachings during those ten nights and would make abundant prayer in *Sujood* during the last third of the night, begging Allah to guide me to what is best for me. God inspired me during those last nights of Ramadan, and I was gifted with peace. I knew what decision I was being guided to. I went on to happily apply to a Muslim college with full certainty that I was making the right decision. I was so sure of the guidance I was receiving that I only applied to that one school. Thankfully, I got accepted.

My senior year went on to be one of the best years of my life. I continued training with my coach and playing for his team, and I was captain of my varsity team that spring as well. At the same time, I kept attending Islamic conferences and events, and I also started organizing and bringing younger people together for good causes. I even started a Muslim Student Association at my high school.

After high school I continued my journey to God and truth, and God has blessed me to continue that path; I pray He allows me to do so until my last breath. The Prophet (*PBUH*) is reported to have said that "prayer is the weapon of the believer." I share this story to show that the power of prayer is real and I know that because I experienced it in a way that changed my life forever.

sheba *39, Phoenix, Arizona, USA*

In 2007, I performed *Umrah*, a pilgrimage to Mecca, with my parents as a single woman. I had completed medical school and was finishing up my residency. The next obvious step was marriage. Many of our prayers were centered around finding the right life partner for me. I prayed my heart out during that *Umrah*, but I was doubtful that I would ever find my soul mate. For the next six years, I tried my best to find my husband. I tried to be open-minded, and to convince myself to settle. I prayed, oh how I prayed! However, Allah (SWT) had other plans for me.

Allah put me through trials that lead to heartache, heartbreak, dis-appointments, and disparaging situations. I believe he did this so I would realize my self-worth and the power I had within me to build myself back up. He had the ability to answer my every prayer, no matter how outlandish. But he wanted me to make mistakes so that I could learn to have faith and to rely upon him. All I wanted was to be married to an educated, good-looking, funny, Pakistani-Muslim man who enjoyed music, movies, and traveling. But the soul mate Allah had made for me far surpassed this list, and anything else I could have dreamt for myself.

Allah required me to have faith in myself and in Him. It wasn't until I reached the point of complete submission, trusted and believed in my heart and soul that every prayer was being heard and answered, that Allah rewarded me for my patience and faith. Allah is all knowing; He hears our prayers. He feels every sting of hot tears, every wrench and twist of a heart in anguish. He hears our cries when we weep alone in the night. Allah tells us to pray and ask for what our heart desires. His condition is that He chooses how to answer our prayers. Holding steadfast to this promise brings us through the tough times to what Allah has ultimately meant for us. I wish I'd known this truth when I was younger.

Nine years after my first *Umrah* trip, I returned with my husband, a DJ turned J.D. He is also a videographer and a photographer, loves to travel, and makes me laugh until my belly aches. He is generous, loving, kind, selfless, and brilliant. He has more virtues than I can even count. Every single prayer I uttered culminated in the soul mate Allah made for me. I went back to Mecca to thank Allah for listening, hearing, and answering my prayers—for granting the ones that were good for me and for refusing the ones that were not. All

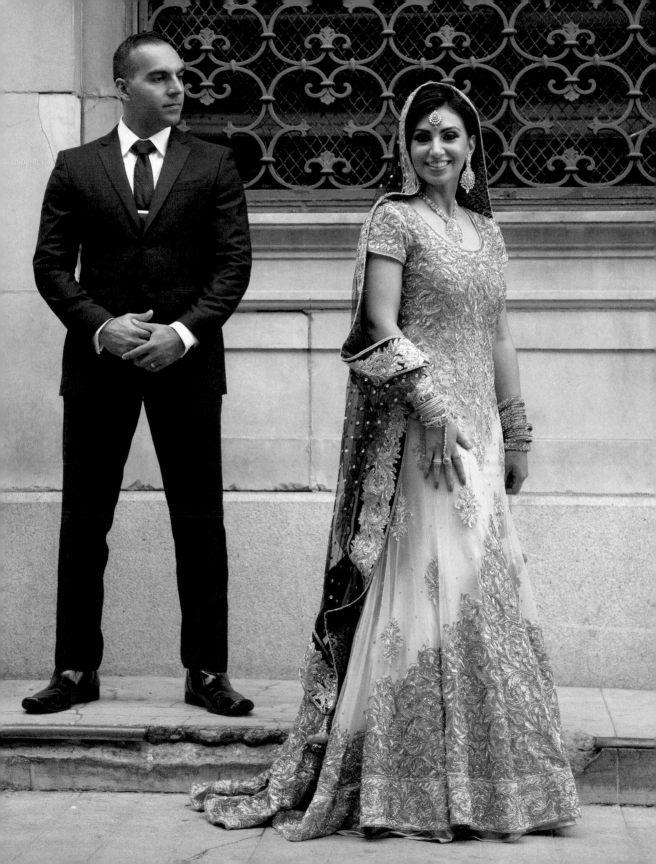

praises to God. My husband has brought bliss and peace to my heart since the day I met him. I never have anxiety anymore. Now when I'm in strife, I close my eyes, pray for better times, and move on knowing that Allah has heard me and is taking care of me.

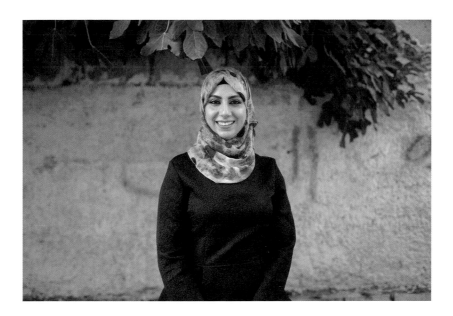

alia *29, Jeddah, Saudi Arabia*

I was breastfeeding my six-month-old baby when I felt strange bumps on the side of my breast. I went to the doctor to get them checked out. At first, she thought they were nothing. But as I was getting dressed she had second thoughts. She checked again and told me I should get a scan. I smiled and thought of the Quran verse, "And give good news to the patient, (Surah Baqarah 2:155) Who say when assailed by adversity: 'Surely we are for God, and to Him we shall return.'" (Surah Baqarah 2:156).

I wasn't worried, because I live such a healthy lifestyle. I eat organic food and exercise, and I don't smoke. But it took three weeks to get the results of the scan, and it felt like three years. When they told me I was sick, all I could think about were my two little boys. I didn't want them to spend their childhoods in the hospital. When I saw the report, I started crying in the hallway of the hospital. I had stage 3 cancer. I put on my sunglasses and cried for an hour, I was so scared. It would take five years to complete my treatment. On my way out of the building, I got lost. Then I said to myself, "I'll have the next five years to learn my way around this building." Life is interesting—I couldn't believe I could be dying while giving life to my child through breastfeeding.

"

Running between
school and the hospital,
and taking care of
my children, led me to
low moments, asking
God, 'What did I
do? Whom did I hurt?'
Then I would get
back up and keep going.

"

I called my husband, then went home. The first thing I did was pray. I prayed hard that God would give me the support I needed. My son saw me, and we cried together. It was heartbreaking. I was supposed to be the one taking care of him, but I was sick and crying. It took me a few days to realize I was about to enter a new stage in my life. I also realized I am not a weak woman! I had always wanted to get my master's degree, so five days after I learned I had stage 3 cancer, I signed up for graduate school.

I had surgery during the last few nights of Ramadan. I wanted to pray and make *Duaa* so badly, but I was in the operating room fighting for my life. The first chemo session was hell. I had headaches, body aches, and I was vomiting. Everything hurt. My son was there sleeping near me. I tried to reach out to him and hold his hand, but I couldn't reach him. I felt destroyed at that moment. The chemo made me lose my hair, eyebrows, and eyelashes. My teeth changed color, my nails fell out, and my face was yellow. It was *Eid* and people came to visit. No one knew what was wrong with me, as I only told close family members. I put on makeup and wore a scarf, but people made terrible comments about my appearance. The comments and staring were almost more painful than the disease itself. I started to believe that I was ugly, until my mom told me, "You are the most beautiful woman on earth, and your face is filled with light."

My new life was three days of class followed by one day of chemo. This would go on for a few months. Running between school and the hospital, and taking care of my children, led me to low moments, asking God, "What did I do? Whom did I hurt?" Then I would get back up and keep going. I started looking at life differently. I appreciated the small things and loved every minute I spent with my children. I avoided saying or doing anything that would hurt another person. My priority was to live in peace and leave a positive mark everywhere I went. I graduated with honors. I was so proud of being able to balance the different aspects of my life.

I have two more years until my treatment is finished, and then hopefully I will be fine. I am tough, and I am facing one of the worst diseases there is. I always ask people to make prayer for me, but you know what I need the most? Encouragement, not pity. Give me your hand, and don't look at me sadly.

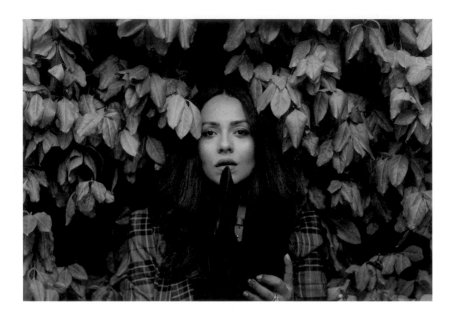

ascia *32, Washington, District of Columbia, USA*

Happy marriages were nonexistent in my world. Every relationship I had wit-
nessed growing up was somehow damaged, either through domestic violence,
adultery, alcohol abuse, or gambling. All of these factors were prevalent within
the Afghan American Muslim community I was raised in. My idea of marriage
had been tainted, especially because of my own household. I never thought of
marrying, and if I was going to, I would never consider marrying an Afghan
American man who claimed to be Muslim only in word and not in practice.
My mother would always reassure me, "A truly committed Muslim man who
understands his faith and its teachings would treat his wife with the utmost
respect, and shower her with love and kindness, just like our beloved Prophet
(*PBUH*)." This advice came from my loving, kindhearted mother who was suf-
fering in her own marriage. Her advice would go in one ear and out the other.

By my senior year in college, I had dated, but nothing ever became
serious enough for me to consider marriage. My life seemed great from the
outside—tons of friends, always socializing, a fantastic job—and I owned my
own home at twenty-two years old, but I was lacking inner peace. I was dis-
connected from the higher power in my life, and it was weighing heavily on
my soul. My job allowed me to take half days on Fridays, which gave me the

"

The struggle to
change my path to
something
more fulfilling was
the toughest
challenge in my life.

"

afternoon to do whatever I'd like. One day, I decided I'd attend *Jummah* prayer, and that day was the beginning of a whole new perspective on life for me. I was guided to His house, and I left with a light ignited inside that I had never known existed before.

The *Khutbah* struck me at my core. It was as if the *Imam* was speaking directly to me! That night, instead of answering my friends' text messages to make plans for the weekend, I answered the calls to prayer. With every *Sujood*, I gained hope and peace, and my eyes were filled with tears of joy. The struggle to change my path to something more fulfilling was the toughest challenge in my life. It meant distancing myself from friendships that encouraged a certain type of behavior, planning ahead to avoid falling into pitfalls of old habits, and learning more about my faith so that I could better understand and practice it daily. I needed to seek Him on my own, and I did. With every step I took toward Him, I found more answers. I began to believe what my mother had shared with me.

Soon I found myself at a crossroads. I had an opportunity to spend the summer in Dubai, or advance in my career. I had read about the *Istikhara* prayer, but I had never done the prayer myself. It is advised to do this special prayer when one needs clarification, guidance, or an answer from Allah (*SWT*). I decided to do this prayer for guidance. I needed to know whether I should leave or stay at home for the summer. As I was planning to do this prayer, I had my birthday party with a few friends from college. One friend brought someone with her. I was introduced to this guy but didn't think anything of it at the time. He reached out to me afterward and we decided to grab coffee with another friend just to get to know each other better. It was a very relaxed outing. We decided to do a lunch another day, but again I didn't think much of it.

When I finally did the prayer, my dream was clear as day. I was in a room full of people, it was loud, full of chaos and turmoil. Suddenly, a man walked in, walked straight to me, and as he got closer, the room quieted down. It was silent. I sensed the most peace I had ever felt in my entire life. It was as if I had arrived home, where I was always meant to be—by his side. It was the same guy!

The man and I decided to continue getting to know each other. As the days progressed, he opened up to me about his commitment to Islam, how he prays five times a day, doesn't drink alcohol, and was looking for a relationship built upon Islamic principles. My mother's prayers had been answered.

From the outside, I never would have imagined he was so committed to our religion. I judged incorrectly. What he practiced, he did for Allah. It wasn't for show or to preach, but to practice purely what our religion teaches us. As he shared his thoughts with me, I knew I was meant to stay at home that summer and see if this relationship would turn into what I was praying it would turn into.

Less than three months later, we were engaged. Six months after that, we were married. Marriage brought many blessings for the both of us: successful careers, many travels, children, and most importantly, the happiness of our parents. Almost eight years later, we have had our third child, and we couldn't imagine a life without each other. And it's all because of the power of prayer, believing, and having faith.

love
You will not believe unless you love each other.
Should I direct you to something that if you
constantly did it, you would love each other? Spread
the greetings of peace among you.
　　　　　　—Prophet Mohammad (*PBUH*)

Shortly after the tragic mass shooting
in Las Vegas on October 1, 2017, a friend
of ours felt compelled to ask us a very
honest question. With regret, he admitted
that his immediate thought when hearing
about the shooting was that a Muslim
must have been the gunman.

He felt that over the past few years he had unknowingly begun to develop a deep association between the words Islam and violence. He brought up examples of why he felt this way from seeing images of the horrific war in Syria, to the bloodshed in the streets of Palestine, to the humanitarian crisis in Yemen. He then asked, "Are Muslims capable of showing any love at all?"

Hearing him ask this question broke our hearts. Negative stereotypes about Islam are everywhere, contributing to a lack of understanding about the world's 1.6 billion Muslims. Hateful rhetoric has become the norm. Society is slowly being crushed by the fear and ignorance that was supposed to "Make America Great Again." Considering the power of this misinformation, we weren't completely surprised that our friend questioned the collective humanity of Muslims.

After discussing this prejudice with our friend, we explained to him that true love is at the heart of the Muslim faith. We spent hours discussing key tenets of a religion that urges its followers to give charity, to fast so that they may know what it is like to go hungry, to have courage in the face of injustice, and to be kind, even to those who are not kind in return. He finally saw that our religion urges its followers to adopt a mutual love, deep intimacy, and affection toward everyone. Muslims believe in a kind of love that is not restricted to one's spouse or partner, but is given to all who surround them, regardless of race, religion, gender, or sexual orientation. This is a love that cannot be distinguished or extinguished. Love in Islam is all-encompassing and sublime, without restrictions or rules. Every relationship, new or old, reminds us of the unending potential of the heart and shows us the transformative power of love.

This is especially important to remember today because it often seems like it's easier to hate than to love. Dr. Martin Luther King Jr. said, "I have decided to stick with love. Hate is too great a burden to bear." In this final chapter we highlight stories about the true nature of Muslims—stories that focus on love, friendship, faith, family, kindness, and hope.

—*Sajjad Shah and Iman Mahoui*

"

I have decided
to stick
with love. Hate
is too great
a burden to bear.

—*Martin Luther King Jr.*

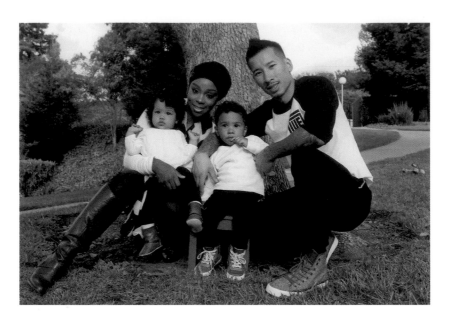

malika *31, San Francisco, California, USA*

I was born and raised as a Muslim. I grew up with seven siblings in a Muslim community. I was lucky enough to have a foundation. After meeting my husband, I realized just how lucky I was. We were young when we found each other. I was twenty-two and he was twenty-three. We quickly fell in love and knew we wanted to spend our lives together. We were so different—I didn't know how it could work. We came from completely different backgrounds. He is Vietnamese and I am African American.

His whole life, my husband was always searching for something: a family, a sense of acceptance, peace of mind. His childhood wasn't easy. His dad was an addict. His mother worked hard but wasn't around, and he often found himself in bad situations. He had little guidance, and he searched for something he couldn't quite grasp. He joined a church and became a Christian. Initially it felt right, like he belonged to something. But soon he found himself in trouble with the law and was sent to jail. He was abandoned by his family and his church. We met one year later and both our lives changed.

We met unconventionally. I was at a motorcycle rally visiting a cousin, and I saw my husband sitting on his Harley. I don't know if it was love at first sight, but within weeks we knew we wanted to be married. But he wasn't Mus-

lim, and I didn't want him to become Muslim for me. He told me he had a friend who was Muslim but didn't know much about our way of life besides its rules. We talked about the beauty of Islam. He started going to the *masjid* on his own. He told me he never felt better. He had found what he was looking for. He had found peace, acceptance, family, mercy, and most of all, love. Now we had to convince my parents that our love was meant to be.

Even though both my parents were also converts to Islam who met and raised a beautiful family, they were not easily swayed. My husband was a young Vietnamese man, covered in tattoos with a spikey Mohawk to match. My dad wasn't thrilled. My husband's race definitely came as a shock, but that wasn't what bothered my father. My father was a very militant, old-school, devout Muslim, and he wanted my husband to remove his tattoos. That wasn't going to happen. My dad also wanted my husband to gain a deeper love for Islam before marrying me, so my husband continued to attend the *masjid* regularly, learning more about Islam. My mother saw our connection, how we both feared our love would not flourish if we didn't take the right steps. Together we were able to convince my dad that our marriage was the right choice.

We both grew up in California, but in different cities. My husband was born in Oakland and grew up in the Bay Area, whereas I lived in Fresno. He was starting a new business and couldn't come back and forth to visit me as often. We wanted to get married as soon as possible so we could live together and start our new lives as husband and wife. We didn't waste time or money on a big ceremony. We married in the *masjid* with our *Imam* and our witnesses. My attire wasn't fancy, and neither was the *masjid*. However, the message was beautiful and pure: *Taqwa*, a mindfulness of our Lord. The *Imam* knew what we were going through and reassured us of our decision to marry. The message was a beautiful reminder to live a life that follows Allah's (SWT) guidance. In the end, it was guidance my husband needed, guidance he was searching for. It was a love story only God could write.

Our story of love and marriage is a lesson: never stop searching for your happiness. Despite the trials and tribulations of life, God knows what is in our best interest. Throughout our relationship, we could have stopped, changed directions, or settled for the hand we were dealt. Where you start out doesn't have to be where you end up. The search for your place in life is always worth it.

dilek *28, Istanbul, Turkey*

I have always loved reading. I was born and raised in a small village that had a tiny library, which is where my friends and I spent most of our time. So many of our childhood memories are from that library. We were even asked to leave once because we talked too much—but we couldn't help it. We found our happy place among what felt like endless rows of books and tables.

When I became a teacher, I was assigned to an area called Sultan Ghazi near Istanbul. The first thing I did when I got there was to look for the library, but there wasn't one. The school was too poor to build one. I shared the idea of creating a library for the school with friends on social media, and I received a great response. So many people offered to help by bringing books, tables, paint, and chairs—whatever we needed. It took weeks and was more challenging and stressful than I expected. But whenever I lost hope, I'd just remember the smell of the books in my childhood library and the joy I felt from reading them. I wanted my students to have those memories, too.

We started off with two hundred books, and in just a few weeks we had a collection of three thousand. I forgot all of my stress over creating the library as soon as it opened. The students were so eager to visit, and so amazed by this humble place. They were excited that they finally had a fun and safe

"

Something special
happens when
children get to choose
books for themselves
and spend their
free time reading about
their favorite topics.
The children I teach
are not rich but
they deserve to be
given every chance for
a better future.

space to hang out. I was thrilled we were able to complete the library because I believe in the importance of encouraging children to read. Something special happens when children get to choose books for themselves and spend their free time reading about their favorite topics. The children I teach are not rich, but they deserve to be given every chance for a better future.

I was recently assigned to a new school. The first thing I did was make sure it had a library. And now, when I think back to that project—a true labor of love—I always think of the student in Sultan Ghazi who told me, "This library looks like the ones we read about in stories."

kiran *31, Dubai, UAE*

I met Mohammad when I was in college, and we fell in love instantly. We waited for our relationship to be official before taking any big steps. Then he proposed, and I was very happy. But our family members clashed. I am *Sunni* and he is *Shia*, two sects of Islam that are usually not on good terms. My parents were okay with my relationship, but other friends and family members were not. Other *Sunni* men started proposing to me—several in one month—claiming they wanted to save me from marrying a *Shia*, which they thought would be a huge mistake. I never thought about Mohammad as "*Shia*"; I always thought of him as just Muslim. One day I asked my father to tell me more about the differences between these two branches of our religion. He was upset and told me that he had raised me to be Muslim, and that differences in sect should not matter because at the end of the day, all Muslims believe in one God.

Mohammad is the eldest son in his family, which means he is held to high expectations. His father did not accept our marriage. It was difficult to try to fit in with his family and to prove to them that I respected everyone, regardless of our minor differences. The first year of our marriage was a challenge. Just like in any marriage, we were getting to know each other, but we also had to think about raising a family. We decided to postpone having children for

"

If she is
comfortable
with her
own religion,
she will
stand strong and
be in peace
with those who
practice
other religions.

"

five years. We worked, traveled, and did everything we wanted to do. Five years into our marriage, Mohammad stopped working with his dad and started a new job. I felt safe knowing that I married a man who would do whatever it takes to save a relationship he believes in. Now we have a beautiful daughter, and with time and patience, Mohammad's whole family has now welcomed me with open arms.

We were scared of facing the reality of how to raise a kid. Each day as our daughter grew, we worked to show her what it means to be Muslim, and to teach her that if she is comfortable with her own religion, she will stand strong and be in peace with those who practice other religions. Before Mohammad and I got married, when we were living in Canada, we met two scholars who have now been best friends of ours for years. One is *Sunni* and the other is *Shia*, yet they share the same space and teach their students how to be good Muslims. These scholars have been our inspiration in difficult times. Eleven years later, we are expecting our second daughter. We are still learning every day how to be understanding and respectful, but we truly believe that love can cure hatred and discrimination, even within our own religion.

heba *24, Amman, Jordan*

I was born to a Moroccan mother and a Palestinian father. They met at a train station and fell in love, just like in a novel. Three years after they met, my dad finally popped the question, and my mother agreed in a heartbeat.

I only remember glimpses of my childhood. I usually have to ask family members about my memories, because I'm afraid I might be imagining things. In the winter of 1997, my mother was diagnosed with brain cancer.

I remember the time she spent in the hospital more than I remember anything else. I would sleep next to her, begging her to come home. I never understood the tears I saw in her eyes when I asked that. She stayed in the hospital for an entire year, and my dad took over all of the family responsibilities. I remember getting ready to visit her at the hospital one day with my sister and two brothers when I saw my dad on the phone, speechless. He hung up and started crying. I walked toward him asking why he was crying. I thought, "Shouldn't he be happy we're seeing Mom today?"

When we walked into her hospital room, she was lying there covered with a white blanket. I was too young to know what death was. All I knew was that she looked too peaceful to be disturbed. Then I realized we would never see her again. I cried along with everyone else. Our lives changed from that

"

I was raised
by a strong man
who turned
me into a strong,
educated,
and ambitious
woman.

point on. My dad would wake up at 5:30 A.M. and make us breakfast and lunch for school. He would get us dressed, drive us to school, and then drive to work. At 2:00 P.M. he would pick us up, fix us a meal, go back to his office, and then come home later to help us study. If one of us had a big test, he would take us to the office so we could study more, and in the morning, he would go over the whole subject with us so we could do well.

He did all of this alone for ten years. He raised the four of us, sent us to the best school, prepared us three meals a day, and kissed us goodnight every night. And, in the middle of doing all of that, he also managed to get his master's degree. He turned from a father into someone who was capable of fulfilling the roles of both father and mother, and, in turn, he became our best friend. Fatherhood is more than a blood relationship. Fatherhood is how a man reacts when he and his family are challenged. I will be forever grateful that I was raised by a strong man who turned me into a strong, educated, and ambitious woman. My dad is my everything.

ali *33, Amman, Jordan*

People judged me based on my weight and I used to be even bigger. I didn't think I would ever find a person who loved me for who I was. When I met Rama, I thought she was charming. I asked her if she would like to have coffee with me. I wasn't serious about being in a relationship, and I didn't think I would call her after our outing. But by the time we finished our coffee, I knew she was the one. I wasn't ready to be in a committed relationship just yet. I had a freelance job that barely made enough to pay for my basic needs. But Rama immediately became my first priority. I explained my financial situation to her, and she still accepted my proposal. We had a small, joyful wedding at the apartment where we would live together. The party was filled with love.

Marriage is not about how much money you have, or how you look. For us it was about trusting that you love and respect your partner, and knowing God will make everything OK. Rama is the reason I pray, the reason I decided to take better care of myself, and the reason I stopped smoking.

A few months after we got married, we opened a shop selling handmade crafts. It was a risk, but it was something we wanted to do together. We always hope we can inspire other couples; if you have love and God you need nothing else. Go and be with the one you love.

eric *27, Ottawa, Ontario, Canada*

When I officially decided to convert to Islam, I didn't mention it to my mom until the morning I was on my way to the *masjid* to say the *Shahada*. She said, "If this is what you want to do, I support you." I didn't know the day I had selected for my conversion was *Eid* and the *masjid* was filled with people when I arrived. I got nervous and decided to go back home, but my mom sent me back because she knew I had been reading about Islam for months before making my decision.

　　Other people in my family got upset when they saw I was reading so much about Islam, but my mom always encouraged me. She never saw my love for this religion as just a phase or something temporary; she knew I was dedicated to it for life. My mom bought halal food for me and even woke me up for *Fajr* because she knew how much I loved going to the *masjid* to pray it.

　　After my conversion, my mom got to know many of the Muslims in the community and now considers them to be some of her closest friends. She spoke with the *Imam* of my *masjid* and the whole community treated her like one of their own. If she saw Muslims around town, she would tell them that her son is Muslim. I would meet people in the *masjid* who had already met her. I would be in the grocery store with my mom and Muslims would smile and say "*Salam*" to her; I would have to ask her who they are because I had never met them before.

Now, years later, my mom still knows many of my Muslim friends and she always talks about how great they are. She asks about every single one when she calls me. She even knows different Arabic words like *Salam*, *Alhamdulillah*, and *insh'Allah*, and uses them herself. Sometimes I wish my mom, and the rest of my family, were Muslim, too. However, I would never force it on them or pressure them, instead, I pray that one day my mom will accept it, *insh'Allah*. A Palestinian man I was close to in my *masjid* always told me to demonstrate the tenets of Islam to my mom through my actions and character, and that would be enough for her to see the beauty of this religion. *Alhamdulillah* the Muslim parents in my *masjid* taught me the importance of mothers in Islam and how I should treat my own mother. My mom isn't Muslim but she has always supported me anyway. I love you, Mom.

esada *23, Istanbul, Turkey*

Ramo and I have known each other since we were kids. We both lived in the same suburb in Bosnia and Herzegovina. We went to the same elementary school but we ended up going to different high schools. In high school, we didn't see each other for a long time as we were both busy with our studies. After high school, I moved to Istanbul to continue my education and he stayed in Bosnia. However, I would come back to Bosnia for holidays and would see him occasionally around town and at social events. Three years ago, I got a message from Ramo asking me to join him and a few other young people for a dinner party for Ramadan. I was surprised he invited me and I decided to say yes.

That dinner brought us together. It was the first time we were both able to talk to one another as adults. We had so much chemistry and we both felt a spark that night. Ramo ended up telling me later that he had wanted to ask for my hand in marriage for several years but didn't think it was practical because I lived in a different country. Despite the distance, we decided to try to get to know one another better. I had two more years of study left in Istanbul, and we would call each other often during that time. I remember during one of our phone calls, I told him that my favorite *surah* in the Quran is Ar-Rahman. Ramo told me he wished he could recite it to me, but he didn't know how to read or recite the Quran.

Around the time of that dinner party during Ramadan, Ramo's mother was diagnosed with cancer. Ramo was very sad during that time and it was difficult for both him and me. They were very close and they shared everything with one another. Ramo needed someone there for him; it isn't easy for anyone to know that their mother may be gone so soon.

After a year of our phone calls, we knew that we wanted to get married. Ramo told his mother and she was so excited. Unfortunately, two months later, she passed away. Ramo took the death of his mother very hard. He was alone in Bosnia and I told him to come visit me in Istanbul. He jumped on the next plane out and headed to see me.

When he arrived in Istanbul, we met and he told me he had a surprise for me. I was expecting roses, a necklace, something like that. He closed his eyes and started reciting, "*Bismillahi-r-rahman ni-r-rahim. Ar-Rahman. . . .*" The man who wasn't able to read the Quran one year ago was now reciting my favorite *surah*! His recitation of the Quran was beautiful and his Arabic was flawless. I was shocked. Little did I know, he had been working in secret this entire time, memorizing and learning my favorite *surah*. I thought, "What more could I possibly wish for?" But then he took out a small box and opened it. It was his mother's engagement ring. She had left it to him, for me. I couldn't help myself; I started to cry.

He told me that even though we both wanted to get married, he had wanted to wait until he learned how to read and recite the Quran before proposing. He told me, "I want our lives to start with Quran, to be filled every minute with Quran, and to end with it, too. You don't deserve anything less. We don't deserve anything less. Let this ring be a reminder that Allah (SWT) is the one who gave us this love, and that we are the ones who should be thanking Him for it every second of our lives. Are you ready for a life with a man who loves you in His name?"

I said yes. We've been married for eight months now. *Alhamdulillah!*

sagal *24, Montreal, Quebec, Canada*

I never imagined being a wife at such a young age. I was only twenty years old when I got married after a three-month engagement—but when you know, you just know.

I met my husband only a year prior to our wedding. He was a young *Imam* who had finished school in Egypt and had immigrated to Montreal. He was continuing his work as an *Imam*, and was also teaching Arabic. That's how we met. I had enrolled in his class hoping to improve my weak Arabic. We didn't have a full conversation for an entire year because I spoke English and he spoke French and Arabic. On the few occasions we did speak, it was about classwork. We had our first real conversation during the last class before summer break began, and I must have sparked his interest. A couple of months later a mutual friend let me know our teacher was interested in marriage. I said no. I couldn't see him as anything other than our Arabic teacher, and we couldn't even speak the same language! I wasn't interested in improving my very poor French, and I still couldn't hold a conversation in Arabic. My friend encouraged me to give him a chance. My parents were willing to meet with him, but they were apprehensive about the idea of marriage because of our different backgrounds. My parents don't speak French, and my father speaks some Arabic, but it didn't matter. When they met him, they loved

him instantly. We continued to get to know each other, and three months later, we decided to get married.

I believe that when two people are meant for each other, Allah (SWT) will find a way for their relationship to work no matter what. Allah has blessed me with a husband who treats me and our children with the utmost love and respect. Not only has our relationship improved my language proficiency in Arabic and French, but it has also allowed me to learn more about our beautiful religion. Differences should not make us uneasy with one another. They should allow us to unite. Diversity makes life beautiful and interesting. How dull life would be if everyone were the same! Marrying someone from another culture has allowed me to understand, love, and respect that culture, and I hope to instill that love of difference in my kids, too.

noor *35, Yorba Linda, California, USA*

It was a very long Friday—a day during which I was loaded with patients at the clinic. I was exhausted and looking forward to wrapping up and going home, when in walked a man holding a hand to his eye. I happened to overhear the conversation he was having with the people at the front desk: The man was begging to be admitted; the pain in his eye was torturous. He explained that some sort of harsh chemical had splashed into his eye and that he could no longer see.

Following protocol, the front desk staff asked about his insurance, to which he replied that he didn't have his information with him. Skeptical, they refused to allow him entry. He left, still clutching his face in tremendous agony. I hesitated for but a second—I knew that I had to do the right thing. Insurance or not, I needed to see this man who was so obviously hurt, assess his situation, and help him. As a doctor and as a Muslim, I am guided by my instinct to show others love and mercy whenever possible.

As I approached him in the parking lot, he looked at me strangely—a look that, as a woman in hijab, has become all too familiar to me. I introduced myself as a doctor and an ophthalmologist. I told him I could not help but overhear what had transpired at the front desk. I asked him to please follow me

back inside so that I could properly examine him. Those huddled around the front desk area looked at me quizzically when we reentered, but I did not care. Helping those in need is what I have been trained to do.

The situation was far more urgent then I had initially assumed. The chemical burn was so severe that his cornea was completely opacified and the surrounding structures were barely identifiable. I knew that this was not going to be a patient I would see just once, prescribe drops to, and send on his way. I would have to examine him daily for at least the next week or two.

Despite the fact that the next day was my day off, I decided to come into the clinic to help him. However, I am only allowed access to the building on weekends when I am on call. I had to place many phone calls in order to find an ER that would allow me to treat this patient on a Saturday. After what seemed like hours, I was finally granted permission to admit the patient to St. Jude's in Fullerton.

The procedure we performed to save this man's eye was a success. The patient was beyond grateful. He actually teared up when he asked me why I was being so very kind, especially without the promise of compensation. I explained that both my medical training and my religious values center on doing good, on helping those who need me. We are taught in the holy Quran in Surah Al-Ma'idah (5:32) that "Saving one life is as if you have saved the whole of humanity . . ."

I can imagine no greater good. This man and I have since become friends. Helping him retain his vision created a meaningful connection between us. That is all the reward I need.

glossary

Abaya: Loose over-garment often worn by Muslim women.

Alhamdulillah: Arabic phrase meaning "all praises and thanks be to Allah."

Alla/Allah: Term for God.

Dabkeh: Arab folk dancing.

Desi: A term used to refer to people, cultures, and products of the Indian sub-continent or South Asia.

Duaa: Term for supplication or prayer.

Eid: An important religious holiday celebrated by Muslims worldwide that marks the end of Ramadan, the Islamic holy month of fasting where Muslims fast from Sunrise to Sunset.

Fajr: One of the five daily prayers required for Muslims.

Hadith: Sayings and actions of the Prophet Muhammad, revered and received as a major source of religious law and moral guidance, second only to the authority of the Quran, the holy book of Islam.

Hafizah: Term used for Muslims who have completely memorized the Quran.

Hajj: The Muslim pilgrimage to Mecca, located in Saudi Arabia, that all Muslims are expected to make at least once during their lifetime.

Hijab: A head covering worn in public by some Muslim women.

Hijabi: A term often used describing a women who wears hijab.

Imam: A leadership position in the Muslim community. It is most commonly used as the title for the worship leader of a mosque.

Iman: In Islamic theology denotes a believer's faith in the metaphysical aspects of Islam.

Inshallah: Arabic phrase meaning "if Allah wills it".

Isha: The last of the five daily prayers that Muslims are obligated to do, done at night.

Istikhara: A special prayer said when one is seeking God's wisdom in an important decision or life event.

Jummah: Congregational prayer that is held every Friday.

Ka'ba: The holiest place in Islam, a large cube-shaped building inside Mecca.

Khutbah: Serves as the primary formal occasion for public preaching in the Islamic tradition; generally takes place every Jummah prayer.

Kufi: a brimless, short, and rounded head covering worn by men in many populations in North Africa, East Africa, Western Africa, and South Asia.

Maghreb: The fourth of five obligatory daily prayers that Muslims do, done just after sunset.

Mashaallah: Arabic phrase meaning "God has willed" or "as God wills" that expresses appreciation, joy, praise, or thankfulness for an event or person that was just mentioned.

Masjid: Worship center for Muslims also referred to as a mosque.

PBUH: Stands for "Peace Be Upon Him." An honorific often said aloud or written after the names of all prophets in the Islamic faith.

Qadr: Fate, divine fore-ordainment, predestination; the concept of divine destiny in Islam.

Quran: The central religious text of Muslims that is believed to be a revelation from God.

Ramadan: The ninth month of the Islamic calendar, observed by Muslims worldwide as a month of fasting to commemorate the first revelation of the Quran to Muhammad.

Sadaqah Jariyah: a form of charity that brings ongoing benefit to others and to you. When you donate to a Sadaqah Jariyah project, you reap the reward in this life and the next.

Salam: Arabic term often used for greeting others, as it is the Arabic word for "peace."

Salat: One of the five pillars in the faith of Islam and an obligatory religious duty for every Muslim. It is a physical, mental, and spiritual act of worship that is observed five times every day at prescribed times.

Shahada: A declaration of one's belief in the oneness of God and the acceptance of Muhammad as God's prophet.

Shaheed: A Muslim martyr.

Shia: A type of Muslim that believe that just as a prophet is appointed by God alone, only God has the prerogative to appoint the successor to his Prophet. Shias believe God chose Ali to be Muhammad's successor.

Subhanallah: Arabic phrase meaning "glory be to Allah."

Sujood: Prostration during prayer.

Sunnah: The verbally transmitted record of the teachings, deeds and sayings, silent permissions (or disapprovals) of the Islamic prophet Muhammad, as well as various reports about Muhammad's companions.

Sunni: The largest denomination of Islam. The name comes from the word Sunnah, referring to the exemplary behavior of the Islamic prophet Muhammad.

Surah / Surat: Arabic term used for a chapter of the Quran.

SWT: An acronym for "Subhanahu Wa Ta'ala" which translates to "may He be praised and exalted." An honorific often said aloud or written after Allah.

Taqwa: Often translated as "piety" or "God-fearing," but a better equivalent would be 'God-consciousness.' It is considered to be the essential quality of a believer to always be thinking of God.

Tawaf: During the hajj and Ummrah, Muslims go around the Ka'ba (the most sacred site in Islam) seven times, in a counterclockwise direction; the first three circuits at a hurried pace, followed by four times, more closely, at a leisurely pace. Tawaf is the ritual circling around the Ka'ba.

Thaub: a garment that covers that entire body from the neck down, often worn by men.

Ummah: Arabic word meaning community.

Umrah: An Islamic pilgrimage to Mecca, performed by Muslims that can be undertaken at any time of the year.

acknowledgments

Prophet Muhammad (*PBUH*) stated, "Whoever has not thanked people, has not thanked God." With this being said, it would take us pages and pages to thank all of the amazing individuals who have helped us on this project. To our close friends, teachers, community members, and families: we are in a great debt to all of you. However, a few individuals stick out in our minds.

In particular, I, Sajjad Shah, want to thank three of my teachers: Sheikh Mohammad Rafiq, who helped proofread our work and helped us explain the beauty of Islam in this book. He went to Mecca and grabbed on to the cloth of the Kaaba and cried out to God for hours to make this book a huge success. Mulana Shamass Nyazee, who sits with me every day at 5 A.M., sacrificing his sleep, to teach me this beautiful religion of Islam, which inspired me to create the "Muslims of the World" concept. Grant Vecera, my writing professor at Butler University—a man who taught me that learning is much more than getting the letter A on a paper. He is also a devout atheist with an extraordinary interest in the idea of God, which we have spent hours going back and forth discussing.

To the Shah Family: Ballal Shah, my father, your heart is so soft and filled with love. Samina Shah, without you I wouldn't know Islam. Hasan, you are just a funny man. Humza, you are too sweet and too caring. Jamal, your love for God is contagious. Adil, your personality, charm, and laughter are what get me out of bed every morning.

I, Iman Mahoui, would like to thank my family and friends for always supporting me. My mother, whose endless generosity and selflessness rivals that of Gandhi, and my father, whose quiet kindness and support have never left me feeling alone in this big world. My sisters and my best friends: Asmaa, my rock and role model, thank you for being a constant light that shines even when the world seems dark at times. And Ilhaam, our baby, thank you for never forgetting who you are and reminding us that each and every one of us is special, not for what we cannot do but for what we can.

To Michael Vivier, thank you for the countless hours you spent on this project. Your work with refugees has served as an inspiration to us all, and for your selfless contribution to this book, we will forever be grateful. To Ala Hamdan, thank you for traveling the world on behalf of this project to help collect some of the most beautiful stories that we have included in this book. To Najeebah Al-Ghadban, our amazing designer, who carefully put each page of this book together in order to match the beauty of this project.

Thank you to the @muslimsoftheworld1 followers, who are at the heart of this project. You have become a giant online family that we care about so much. We have accomplished so many amazing things together, from raising hundreds of thousands of dollars for people in need to bringing a voice to those who aren't always heard, to writing this book. *Muslims of the World* is yours as much as it is ours, and we hope you love it as much as we do.

Editors: Samantha Weiner and Emma Jacobs
Designer: Najeebah Al-Ghadban
Production Manager: Rebecca Westall

Library of Congress Control Number: 2017956860

ISBN: 978-1-4197-3248-5
eISBN: 978-1-68335-347-8

Text copyright © 2018 Sajjad Shah and Iman Mahoui

Portraits of Mahmoud (p. 24), Naser (p. 28 & bottom row
center of front cover), Jarrah (p. 35), Mahmoud (p. 59), Sana'a
(p. 63), Rafal (p. 65), Wesam (p. 69), Mohammed (p. 72),
Lubna (p. 75 & back flap), Motasem (p. 89 & top row left of front
cover), Rowaida (p. 110), Adwaa (p. 118), Shabnam (p. 122),
Hadeel (p. 147), Eman (p. 150), Rana (p. 153 & bottom row right
of front cover), Hadeel (p. 155), Atika (p. 163), Khaled (p. 175),
Anjum (p. 177), Alia (p. 189 & middle row left of front cover),
Dilek (p. 202), Kiran (p. 205), Heba (p. 208), and Ali (p. 211)
by Ala Hamdan

Portrait of Chad (p. 20) by Mariam Gamal

Portraits of Abdulwahab (p. 27), Sidelemine (p. 41), and Yaseen
(p. 180) by Rashid Kadura

Author portrait of Sajjad Shah (back flap), photo for Safaa's
story (p. 30), and portrait of Shamaas (p. 129) by Kyle Thacker

Portrait of Sara (p. 114) by Acres Photography

Portrait of Abass (p. 182 & back cover) by Nadia El-Khatib

Cover © 2018 Abrams

Printed and bound in the United States
10 9 8 7 6 5 4 3 2 1

Abrams Image books are available at special discounts when
purchased in quantity for premiums and promotions as well as
fundraising or educational use. Special editions can also be created
to specification. For details, contact specialsales@abramsbooks.
com or the address below.

Abrams Image® is a registered trademark of Harry N. Abrams, Inc.

ABRAMS The Art of Books
195 Broadway, New York, NY 10007
abramsbooks.com